LIGN SERIES

Figured Stones

Paul Prudence

XYLEM BOOKS 2022

LIGN SERIES

LS1 Oliver Southall, *Borage Blue*

LS2 Gerry Loose, *The Great Book of the Woods*

LS3 Jennifer Spector, *Hithe*

LS4 Kim Dorman, *Kerala Journal*

LS5 Paul Prudence, *Figured Stones*

Paul Prudence, *Figured Stones*
First published in 2022 by Xylem Books

Cover image by Paul Prudence

ISBN: 978-1-9163935-7-8

Xylem Books is an imprint of Corbel Stone Press

Figured Stones

Exploring the Lithic Imaginary

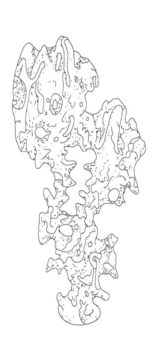

INTRODUCTION

All over the world are scattered stones that contain tiny kingdoms of petrified forests and model mountains. These stones, with their imagined societies of people, their animals and mythical creatures, await to do trade and form alliances. In each rock you may find exotic gardens, encrusted cliffs and the wrecks of ruined palaces. And every space is overrun by lichens, vines and exotic herbs. That 'figured stones' have been prized for their mimicry of miniature topographies of Lilliputian beauty is well attested by the great collections as far back as the T'ang dynasty. But even before that era of great adoration, these rocks had already weathered their apparitions into the human imagination. The pre T'ang literature tells of strange rocks in wild places that took the form of

dragons, saints and even monsters. And the metaphysics of the microcosm found an early apogee in the emperor's magic monuments made entirely from these stones.[1]

Erosion, whose secrets are occluded only by time itself, has been busy; slowly dissolving rough rock into miniature worlds. The flow of water – that fertile archetype of time itself – has worn tiny rivers and valleys into stone, copying those processes of the greater world. Time flows through water and time flows through rocks, transforming them into mirror-worlds by attrition. And with more time these tiny streams in stone are turned into caves and tunnels which burrow down into the foundations of our own subconscious worlds. These sunless chambers form the perfect refuges for the dreamt-up denizens of our inflamed imaginations.

Nature has summoned its blind forces to create a fractal dimension, for each rock is a replica that exposes all the processes by which the world fully reveals – and comprehends – itself. As diminished echoes of the earth's own features, figured stones offer us foci for studying a sense of planetary introspection. In depicting the greater essences of its smaller self, nature's trick becomes a form of self-awareness – nature's 'that I am' is cast into solid conscious form as the geological recollections of a former world are made manifest. The ghosts of stratified histories cascade through time and leave their marks in rock as totems or as scripts, or as tiny worlds, complete.

MINIATURISM & DIMENSIONALITY

To enter such miniature worlds we must first descend
to the surface of these rocks. And as our imagination
lowers itself onto these tiny vistas we become unchained
from the conventions of ordinary space-time; or at least
we mould their conventions according to our whims.
Minutes tick in micro-time or else obey the magnitudes
of aeons. Space is measured as an inverse of its real
dimensions. It becomes limitlessly vast in the mesa of the
mind's eye. As the imagination falls through this nexus
of scales it moves through the blood-brain barrier of
dimensionality. And as we approach the event horizon of
these colliding scales we may experience a momentary
blackout and a split second's journey through utter dark-
ness. Then we awake as castaways upon a floating island

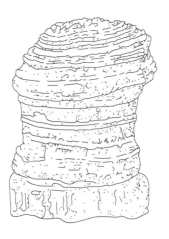

made of stone (that famous levitation trick gifted to us by Magritte).[2] Returned to our smallest selves we have returned to the moment of our most potent childhood imagination and we are free to survey every inch of our newly won kingdom from any angle. Our sense of agency is sharpened by the fantasy of this newly unlocked liberty. The shrunken self has spelunked through the optic nerve and our bodies have become irrelevant. We are free to begin the great eye-brain expedition. Imagination – connecting worlds and connecting scales – is ready for adventure. There is no limit to our gaze in space as it burrows deeper through the spectra of visible features. We become high on the drug of spatial convergence – for here, in this looking-glass world, potency of space is an inverse of its scale.

By mimicking the greater landscapes from which they emerge, figured stones reference the complete archive of geology, and as lithic compression artefacts they act as a key to a whole. These small replicas of larger prospects justify that well-worn maxim of connectivity and continuity – *as above so below*. But, by some odd equivalence, they also allow us to relinquish our ties to that trusted falsity – *the bigger picture*. In this newfound province all rules are of our own making and we are free to explore by foot, or, by rejecting the rooted tyranny of gravity, by wing. And, rather than dilute the power of the original, miniaturisation fortifies the things it copies for

it's through the inversion of scale (and proximity) that nature becomes distilled into its most primal essence – a reductive abstraction that remakes the world as a model of excellence. Tiny objects become archetypes and allegories of the larger world without losing any of their power.

At first arrival it may appear that we are the sole inhabitant of this island of stone. But soon that thought dissolves as the crags and scarps twist their forms into living beings. Disembodied, the lively eye darts swiftly and acrobatically across the terrain, hugging the ground or viewing from multiple perspectives. It clambers, it flies and it spies from above. And is it any coincidence that each night on earth our dreams are full of such flighted manoeuvres, as if in preparation for these disembodied encounters? The omnipotent eye can now view from any aspect. It has night vision and limitless zoom. It moves millimetres above the lithic canopy observing the details. And, in diving deeper to scan the fractal dimensions below, its view is pierced by clusters of flares. Dots of light race like tiny coronal mass ejections across the lens of the eye. Dancing green epicycloids and red roulette deltoids are the iridescent emblems of this newly found supernatural sight.

Probing deep into the mulch of petrified leaves we find a patchwork of lichens in various colours, and small groups of spores that dapple the rock in infinitesimal shades. *Graphis scripta* unfolds its secret writing over the

ossified bark of a tree. This lichen can be linear or star-shaped, or even take the form of miniature labyrinths in writing. These tiny mazes-as-letters form natural ciphers and sometimes *scripta's* glyphs approximate animals or demons so that its lithic vocabulary doubles as a divinatory system. Eyes trace out oracles and omens through its labyrinths of puzzles.

By descending through the sequence of scales we find ourselves spiralling backwards through the spectra of time. In visioning the incredibly small we approach our earliest memories because all experiences of miniaturising converge us towards that common reference of mossy forests and mushroom shelters, and of lawns with vast societies of ants and leaves that mimic great barques in rivers of rain. The rewinding of time by the contraction of space returns us to those half-remembered inklings of a former, younger life. And perhaps if we keep reducing the scale and rewinding the tape eventually we may need to be reborn. Time and space – the fulcrums of our invention – pull on one another so that each is always contracting or expanding. Time may run faster in some places and slower in others; and what if our minuscule self loses its way to trespass the boundary of our island of stone?

The vertiginous descent can only go so far. Imagination falters as it approaches the furthest reaches of microfication. And, as with the Eames's *Powers of Ten,*

the vivid outlines of figures and forms eventually disintegrate into a fuzz of meaningless noise.[3] Like the magnified grain of a film it is a storm of chaos without anchor. We have exceeded too many levels of recursion and have become removed from any reference to scale. The force of reduction rebounds us back off into space. But luckily for us any adept of miniaturisation is also a master of gigantism. And, since both the tiny and the gargantuan displacements of self conform to the common seam of a disembodied continuum, our reversed migration through space leaves us unscathed. In the distance the receding rock creates a new species of smallness as we view it from afar, deciphering its landforms as the shapes on a map. Though our agency is lost to the distance we gain new perspectives because that distance subdues and dilates time. And so the serrations in stone – that once defined the crenulations of a miniature bastion – now sign the coastline of an ancient Tethys surging towards its future state. Landforms flutter and flow in intensive time-lapse as an imperceptible slowness is brought into view. We witness, for the first time, the metamorphic intent of geology as it boils its forms into the language of geographical history. Earth – that grounded symbol of fixed solidity – seems ephemeral and vaporous; a liquid globe of shifting patterns that vindicate those who champion clouds as the model from which to study the earth in formation.

In contemplating distance we create another category of the small and a different kind of mystery. When we wonder what might exist beyond the horizon – what waits beyond the edges of a distant woodland – we are already moving through the dimensions. And as we imagine forest elementals gathering magic deep within the concealment of roots and rhizomes, our vision has moved across the range of scales with an effortless motility; we have transitioned from the near to the far, from the within to the without.

On earth we relinquish control to fate by imagining greater beings controlling us like pieces on a chessboard. Gods look down upon us and see us as their pawns, their miniature playthings. As slaves to scale we yearn for freedom from that fate. Figured stones grant us escape so that we might find even smaller denizens and be their gods. The tendency to miniaturise the world, then, is allied with the impulse to escape it. There is a famous story of a Chinese painter who disappears into the landscape he has painted.[4] Stepping into pictures and stepping through dimensions is a revelatory act of transformation. It is an occult departure from consensual physics and an escape from the society of material dominion.

Imagine a place upon a stone. Enlarge that stone and then walk the path you find upon it. Note the things you see while walking and know that everything you see is already contained within you. Like stones, we are

also microcosms of the world and a stone can reveal this knowledge.

Note: To effectively miniaturise space we must be a lone surveyor of our kingdom. A world delicately suspended in the imagination is subject to distraction – or, worse, threatened – by that most invasive of species – the subjectivity of others.

TRANSCRIPTS OF RHEOLOGY

The undulating forms in stone can convey the laws of
fluid flow and encode the unseen trends of liquid motion.
The hydrologic cycle has found a means to record in
rock its moods and to concatenate them all into a single
totem. Taihu rocks record the swells, the eddies and all
the rarest ripples (with the delicacy of any sense organ).
They chronicle the currents that move across the surface
and return the motions of unseen tides that sculpt below.
Their fluid shapes are clear transcriptions of a blind
intent made visible for human eyes to see. Rheology has
impressed its character in a summed articulation of every
seiche and bathymetric spiral, of every ebb and flow.[5]
Water is a living manifold whose calculations are fated to
be resolved in stone.

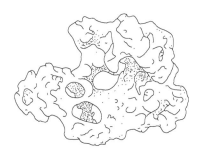

Each rock is a wave equation – a complex model of bifurcation and wave formation. The involutions of unstable gestures have made an avatar of mathematical conjecture, and like holograms of time feeling space to predict a future state, each curve in stone foresaw a future boundary state to return its figured sum. But perception, distracted by the rock's baroque designs, may forget the secret forces that framed its final form – the tiny interferences, the micro-instabilities, and the Laplacian quests of flow regimes. Endless habits carved to stone as the tireless sculptor of the manifold weaves its liquid signals into space. Shells may store the sounds of waves, but Taihu stones compile the liquid physics into an alphabet of epsilons and upsilons – the sinusoidal cells of tidal swells and the shapes that sign the lunar paths.

There are whorls that sculpt some rocks into spiral casts like plaits of Gorgon hair in snaked extrusions. Streams of turbulence create concavities and curlicues in broken loops; the ellipticals of forgotten oxbows and abandoned half-moon runes. The helices of Rumi rocked by nature's rhythms where every species of knot abounds, and every quirk of sinuosity is expounded. Lakes may undulate, but rivers carve and sharpen.

And there are vortex stones which recall each river's dervish. They reel the river's path back to points were whirlpools once prevailed. A rock, a spire, a twisted

tower that churns the trails of unseen water. And when placed in rooms these spiral stones emit their cyclotronic forces and eyes that fall upon them are sent in gyres, and roving bodies are pulled around them in grace-ful arcs (like comets bending past the earth). In any realm of sacred walking we adjust our paths to interact with such unseen forces. The inward pull of mounds and monoliths, and their centripetal forces, catch and throw us. Their hidden forcefields coax us onwards – our wanderings are thus constrained to trails of psychic circles (the Buddhist *stupa*, too, prefers a clockwise motion to appease the spirit of the vortex). And so these spiral stones become guides to providential arcs as they curve the chants of oft-repeated words into our walks. Invocations embedded in the routes we traverse so that our spirits complete the broken circles. What need is there for transmutation when enshrouded in such self-inclusive systems? As time eddies through the water it draws its vortex back to the crown of rock where a light cone spins in darkness – a twisting lingam held within a coiled event horizon.

The shapes of rocks may recall the furore and frenzy of the rapids but sometimes all that turmoil is conferred as something simpler (a material contract that dissipates all complexity into an honest spareness). Rock and water, it seems, collaborate to find the forms most compliant to each other's needs. It's a point of interest that in this

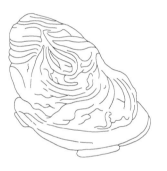

invisible realm of entangled process something so solid – a rock – should find such time-worn company with that archetype of formlessness – water. In sculpting rock, water creates an affirmation of its own intention and the rock becomes a ruse to the water's fate. A paradox of agency – for rock receives the form of the thing it tries to stop, while water takes the form of the thing it tries to mould. So, here the soliloquy of water is refrained by the rock's returning of its flow (a conversation between two things forever trying to find their stable state).

Certain rocks are smoothed into undulating curves with scale-like shapes to propose the streamlined contours of living forms. Curves may echo the lateral fins or the dorsal frills of animals evolved for aquatic locomotion. Flexed or rounded, ciliate or lunate, these are shapes seemingly primed for propulsion. The bodies of these rocks have been resolved to glide in endless currents, suggesting the forms of a forgotten aquatic species yielding to the liquid process. They present to us a fossilised 'awareness' that rends materiality into a surrendered state in order to reveal the traits of evolution.

Some figured stones are etched with such an abundance of arcs and dots that they form a dense plane of kinetic hieroglyphs. Like the magical scripts of Mark Tobey or Henri Michaux, this writing floats in space like charged electricity or the persisting trails of ionised particles. Liquefied ligatures suggest the intimacies of

flow and become the true data visualisations of fluid dynamics. The lobes and eyes of the letters contain little ponds and in these apertures you may hear the faint sound of reverberating drips. This turbulent notation of hydrographic glyphs is pure-form writing. Water as a writer of scripts competes only with the clouds. And as Taoists know all too well (and as if to mock their own hands), the message it writes in stone is always the same: 'perhaps, you cannot do better then me?'

Conceived by this invisible hand of rheology, the ripples and whorls may further sculpt the rock into an image of what? An image of itself. Time wears on and the stone becomes its own caricature, refining its own form by forcing the flow of water into echoes of its future shape. Feedback curves reverberate through the liquid-memory space, propagating themselves as sculptural carrier waves. Erosion has become an echolocation system slowed to the point of never receiving back its projected signal. This is attrition as geophysical solipsism. And, as the decades roll by, the same mantra is repeated, rewritten so that each twist in flow and turn in tide is recorded and remembered with a groove or a line. Small shifts in flow amend and revise the annotations so that the stone evolves a portrait of its own formation.

The jagged striations that contour some stones (those pencil lines that notate the diminishing echoes of each stone's form) repeat towards a proposed infinity and

project a scheme towards a future shape. These sinuous lines etched by currents are cryptic tidal almanacs and memorials to each diurnal pull – the wax and wane of a lunar gravity consigned to lithic memory. And who can say? Perhaps all rocks contain a memory of some ancient phase or recall the tangle of some distant cosmic path. Somewhere held captive in stone a secret astral trajectory is waiting to be known.

THE STONE CATALOGUE OF THE TRANSFIGURED GAZE

Cloudstones

A Jiangsu dreamstone, a Yingde cloudstone, a fog-remnant-stone pulled from Lake Taihu – these are stones as frozen clouds or fossil scripts floating in shrouds of mist. Crammed with a webwork of curves – the enmeshed ascenders and descenders of an asemic cursive – these stones form a numinous cloud calligraphy or a broken Kufic as ornamental as any creeping vine. The negative spaces enclosed within their glyphs create an inverse prayer matrix for a hollow-earth invocation. This is writing as visionary topocosm, where geology and vocabulary are baked into a single codex. And is it not apt that the imagination weathers its perception of stone to resemble the most archetypal of pareidolic forms – the cloud? As children of a larger group of phantom forms both stone

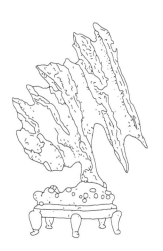

and cloud are mirrors to each other's transmutability. Both encapsulate (and symbolise) the larger class of dreamt-up forms. Like clouds, rocks reject perceptual fixity. Their continually shifting forms are ever keen to snatch prizes from the eager void. No degree of erosion can ever erase these scripts from stone: in fact, paradoxically, it can only add to these palimpsestic ruses.

If we speed up the choreography of geology by an improbable factor what we see are shapes that move like clouds – twisting, transforming, evanescing. From this we know that the earth in formation can be understood by observing the sky (for clouds are narratives of maps in motion; the images of evolving grounds and dissolving regions). Taoists and geologists, united in their common awe of temporal boundaries, have long since sensed the connection between cloud and stone. They connect the things that form in instants with the things that form through aeons. They embrace the circularity of these durations through meditation or through fieldwork, and they see clouds and stones as tokens of a deeper continuum. Students of the earth (and those who find themselves disembodied by geology) are content with this extended space of durations. They are in commune with stones and find community with the clouds. In lithic meditation (or deep-time introspection) they are brought towards a timeless material indivisibility.

In the Taoist tradition clouds represent the indifference

a sage aims to gain towards the body or the physical manifestation of the world. They represent a kind of disappearance that must be attained. They symbolise the path to annihilation and the sacrifice the sage must make in renouncing their mortal being. The apposite stone, then, registers an uncanny counterpoint to the endless duration of deep time and positions the body as palpably insignificant – paradoxically – to the point of omnipotence in the redeeming power of ineffable presence. In her extraordinarily epigenetic deep-time meditation on the geological formation of the British Isles, *A Land*, Jacquetta Hawkes returns often to the image of clouds, tapping into their forms and motions as a way to connect with, and describe, otherwise incommunicable ideas of geological consciousness and memory. Her powerfully poetic passages invoke a timeless prehistory: 'The clouds are all around me ... this luminous but impenetrable envelope of greyness. It smothers not only all observation but all thought. I am conscious of nothing but consciousness, held here on a rock and engulfed by chaos.'[6] Hawkes's receiver is not tuned to a biological timescale but to prehistorical geological memory. Like a Taoist she meditates herself towards the stone's inner essence to find a way to access the solid-state memory that has somehow left its mark in the stores of human consciousness.

The spiritual impulse to transcend the body marks a special aspect of mind. The urge to commute beyond

the flesh finds focus in the alien shapes of geology that, themselves, transcend the flow of time. If clouds symbolise human ephemerality, then rocks affirm the limits of human agency. And this is why both clouds and stones have found their way into the collective unconscious as symbols for our deepest metaphysical questions on the nature of impermanence and the paradox of time.

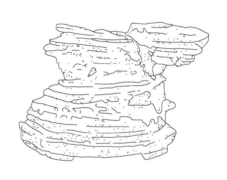

Landscape & Sediment Stones

There are certain rocks that mimic, in entirety, the
stratifications of the earth's own crust. Magic lantern-lit
landscapes with zoned sediments copy the ply of an
extravagant cake. Silt and swamp, shale and sand are
compressed into slithers and streaks, and everything
seems painted by hand. Erosive forces have exposed
the veneers of a compressed history, shedding light
on the mantles of time. These little crust-cut scenes of
red-glazed land may also contain rivulets of silver that
thread through the rock like veins of quicksilver. Lacing
through, they subdivide the rock into small tracts of land
in measured sections – the lines of an ornate calligra-
phy freshly written upon the earth. Run-off channels
subdivide these sections further into smaller reflexive
diamonds. Cracks angle their stratagems in tangled
trajectories, creating cryptic graphs that fork their clues
downwards towards unseen aspects of the mantle below
– a tattered script of knotted cursives that cuts through
the crust like enraged lightning. Cirques and pikes spell
out the icons of an enigmatic new-found land and a
new-found language; a seam of cuneiform engraved upon
an oracular map. Ravines twist back and forth like the
teeth of a gigantic gear, for somewhere below there must
be a machine cutting this notation of valleys. Knolls roll
through the ridges as the valleys roll through the range.

Often the cadence is broken, for it seems the sections of time have been dealt from a deck with a shuffle. The continuity of space is disjointed and the narration is broken. Volcanic ash vies with erratic lodes of precious metals. Peat and shell are interspersed with shale. Varves jostle with ventifacts and mounds wrestle with knolls. And in every layer randomly ordered fossils ruffle the guise of any intelligible sequence. Minerals that don't belong together have been brought into proximity. Like books whose pages have been randomly reordered, these rocks assume the role of a puzzle. Geology always presents time as a ruse. But even in this fractured state time cannot be entirely thrown from its axis and there are still hints of a direction of flow like those wind-worn nodules of flint that sweep towards some unknown, but definite, rendezvous in Yves Tanguy's paintings.

In these mimetic rocks we find hints of all kinds of enigmatic brushwork. From the spare mysteries of Paul Nash to the generous shades of Georgia O'Keeffe, here paintings are born into three dimensions. Here rock declivities absorb the sunset mode and diffuse it back in rushes of height-mapped twilight. Shaded pinks create hazy horizons and processions of ranges. Red gradients mark ridge beyond ridge and silhouette beyond profile. Sunlight shifts beyond shadow as shadow moves beyond the limits of light. Every terrestrial scape is to be found in these stones, from the painted deserts and the scoria

badlands to the golden amphitheatres and the vermil-
ion sands. But here too are the features of more distant
terrains. In moon-splashed light these rocks quote the
landforms of interplanetary spaces – the gulleys of the
Sinus Sabaeus and the *Fossae of Sirenum*. In crepuscular
light, mauve shadows creep across Martian deserts; their
umbras ring out the circles of craters. Outlines in half-
light ride the red-dust plains and reveal the arcs of ejecta
and other crustal pathologies of a Martian skin disorder.

Mapstones

Everything we know about our terrain and its topo-
graphic features was revealed to us in *mapstones*. The
shapes and lines inscribed upon their surface and the
little petroglyphic signs that matched our cartographic
legends repeated every detail of the geography we discov-
ered along the way. The pebbles that we found were the
mappae mundi of this world (or another yet to be). And
everywhere we saw these stones we found predictions of
our future destinations. For what purpose was this link-
age between topography and texture? Rocks, it seems,
have primed the brain for unpacking flatness. They have
tuned the mind to extrapolate from levelled textures
the vastness of the spatial landscape. And as the mind
plumbs the depths of spatiality by referencing geology it's
obliged to return its own legends back to rocks. A map
embellished in the mind becomes a sigil of a place and a
stone may further frame that simple sign.

As a nomad wires her spires of navigation into mem-
ory, a stone may become the store of signs to aid her on
her way (both through real terrain and psychic space).
Mapstones, then, are the cosmograms of imagined
voyages. They signify the routes to future places and can
offer precognitions of the flavour of each journey's end.
They condense the routes of voyages and emblematise
our commute through time and space. They encode our

spatial superstitions into the mythos of their delineations. Their lines say 'go this way, go that way' as they guide us through the wild terrains. And in their mess of scratches we read the fractured shapes as maps of future place-memories. Our impressions of the bounded space were gathered from the stars and corroborated in the shapes of the rocks we kept beside us.

Some of the oldest known maps are etched onto stone. In Europe carved 'mapstone' slabs have been found in cists – stone-built ossuaries used to hold the bodies of the dead. The surfaces of these stones are scored with lines and interspersed with repeated signs and glyphs – a signage representing the local rivers, hills and surrounding landscape. These artefacts, with their tactile three-dimensionality, predate our own paper terrain maps by thousands of years. In engraving landscapes onto stone the rocks become mnemonic aids to the space of the imagination, and for the navigation of space. Mapstones are a vivid testimony of the cartographic expertise and sophistication of prehistoric societies. We can only speculate on the qualities these people sought when selecting stones to be honed into their landscape miniatures – most likely a mimicry of the terrain which was eventually to be carved onto them.

Architectural Stones

The processes of geology have transformed certain other rocks into dense assemblages of towers and columns. Great masses of obelisks point maniacally to the sky. Pillars graph their way through one another, proliferating like breeding steeples; a mess of wax-melted stalagmites and Gaudí-esque spires. Palaces rise in staggered steps, decorated with misshapen gods and goddesses. Emptied canals, their beds blackened with soot, weave through these structures like the veins of an obsidian residue. Fluted tufa stacks project black blades into the sky and cast satanic shadows upon the ground.

Distance breeds distance in this indefinite space. Every detail is echoed in every dimension. Pinnacles roll past pinnacles and waves move beyond waves. Buttresses cut the horizon into regular scores and create rows of rock antennae. Turrets cluster like fungi. Everything seems encrusted with polyps, like a city of coral raised from the ocean and coated with the deposits of embittered memories. Needles emerge like lances, or the masts of great ships wrecked in the Antarctic. Geology has revised its strange aberrations into a skeletal city. A graveyard of broken monuments and eroded cenotaphs. Headstones tilt haphazardly like the hands of a clock frozen in time. A fractious scape of bone balustrades and corroded caryatids supporting ruined plinths. This city in

rock, with its confusion of shadows, is a feast for the eye but a place for the dead.

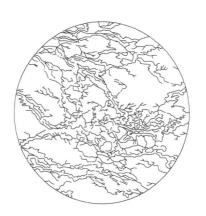

Dreamstones

A rock may bring with it the aesthetics of its geography but from time to time it may also fetch the specifics of a climate too. Its pattern may recall the weather of the surrounding landscape in which it was found or formed.

In the golden gradients of their ruin marbles Florentines saw hazy glowing sunsets with relics bathed in the expansive light of Tuscany.[7] They imagined skies filled with shades of cerulean blue and flushed with glares of gold. They painted little figures on the surfaces of these stones to emphasize the landscapes that they saw, complete with bastions and medieval ramparts. For Tuscan lapidarists each stone was a window into a world of monolithic mirages cast in cloudless skies – ancient ruins given shape by the unearthly light of dawn. The Chinese, on the other hand, saw auspicious peaks enshrined in mist and swirling clouds within their marble wedges. They mounted slabs of polished stone in frames of ornate hardwood and positioned them on plinths in rooms to act as portals to the other worlds. Though often viewed as scenic landscapes these natural stone paintings (called *dreamstones*) could also double up as atlases of atmospheric vapour. With their delicate shaded greys and whirled striations, they were clear facsimiles of the nearby weather patterns that matched the spirit of the local climates.

Almost all the Dreamstone mined in China was – and still is – extracted from the ancient settlement of Dali, a town near the snow-capped peaks in the Yunnan Province famed for its mountain walkway called 'Jade-Cloud Road'.[8] It is a place of spectacular cloud formations that drift majestically over the nearby mountains. And by some proficient turn – with that polished trick of mimicry – nature has recorded these cloud patterns and zones of mist within its marble indices. The most delicate vapours are frozen into rock and preserved for all eternity. We can see the 'castellanus' cirriform with turret shapes, the 'fractus' broken, stratiform, and the hook-like 'uncinus' of the shyer cirriform. Soft white and limonite seams purge their way through the dark green veins and brush the swash of sky away. In this fanning scroll of diffused reactions we can find the lines of isograms and the tiny arrow-headed flecks that suggest those diagrams of wind-speed systems.

It takes a certain skill to cut an otherwise unimpressive lump of rock; a skill to see into its secret centre. Familiarity with the outer shape will guide the lapidarist, just as certain landscape features may guide the walker. A reading of a rock, then, is like the reading of the way, and to make the perfect cut requires some lithic intuition and a leap of faith into the hermetic heart of things. To find the most auspicious scenes and locate the greatest atmospheric treasures may take years of

clairvoyant practice, and a kind of projective visioning of what one hopes to find when the magic is accomplished. Just a millimetric shift at the point of entry will decide the difference between two different worlds; between two different galaxies. But years of cutting sharpens the senses and fine-tunes the ritual intuition for where the perfect cut may lie.

Sometimes, though, the cut may display a confusing plane and confound a sense of vantage. Something miraculous, that was impossible to preconceive, is granted. All perspectives seem contained within a single view so that a scene may shift from moonlit surf to hyperboreal sunset depending on the angle of inspection. Flattened facets form phase diagrams – the ghosted contours of imagined lands smeared from three-dimensionality into flatness – as if the landscape itself were cut into thin film slices and arranged within an atlas.

Sometimes the filaments of marble look like those combed and threaded decorations you see in the endpapers of certain antique books. Metallic hues stream through the rock, like optic fibres arranged as signs and sigils. Geology has become a broker, bringing an alchemy to the body of the earth.

The Dali marbles of the Yunnan Province share their name with an artist who painted objects not as a fixed things but as mutable extensions of his inner world. And perhaps there is no better way of understanding the

method of extraction of all our lithic apparitions than to study the process used by the great surrealist to invoke *his* phantoms. Conjuring images through irrational association and discontinuous interpretation, Salvador Dalí set out to taxonomise the index fossils of his mind by painting lush psychoanalytic scenes. Topography and geology framed his subjects. He used landform masses combined with human figures to breach the boundaries (and transduce the secret meanings) contained within the landscape of his psyche.

According to Xu Xiake, adventurer and geographer of the seventeenth century, the artistry of Dali marble was so perfect that no one could paint a better natural scene.[9] Its facsimiles of mountain mists remained unsurpassed. And if no painting could compare to the earth's own work then why not leave nature to do all the artistry. For Xiake, only Dali marble could convey the true essence of nature, and any gallery without such stones was not worth visiting.

Like well-used mirrors, Dreamstones are the silent witnesses to all those who have scrutinised their marks and journeyed through their vistas. Charged by longing eyes, they encode the moods of those who look upon them and hold within their marble swells all their for-gotten conversations. Beyond these worlds of mountain views, the reveries of every ancient dynasty can be read within their marble swirls.

Decalcomanic Stones

There are certain Lingbi stones alive with biomorphic forms. They contain a mess of eyes, entangled limbs and embedded wings. Creatures large and small are concealed within a bestial camouflage. A glue of feathers scratched with signs, the pictograms of bird and bat bone. Here are scripts ossified within a solid honey structure – missives written with the wings and hairs of insects. Fossilised trails inscribe a hieroglyphic fantasy in stone – a *bestiarum vocabulum* of frozen syntax written at a point of sudden cataclysm. And though it seems an eternity has passed since their last breaths were drawn, these animals might seem to stir at any moment with their memories of former worlds flooding back. For now, though, these creatures must lie in wait for the aqua vitae of rejuvenation, just like those animals entombed inside the crystal worlds of Max Ernst's paintings. Ernst used decalcomania to pull at paint and coax its viscosity into revealing a delirium of lifeforms. Under his self-invoked spell of form-insinuation he reworked the chaotic textures into entire worlds so that discord was exchanged for order and an evolution granted with a kind of aesthetic natural selection. By reworking capricious textures into forests and animals, Ernst would re-enact those strategies used by the artisans of marble who painted tiny figures onto stones to accentuate the visions that they

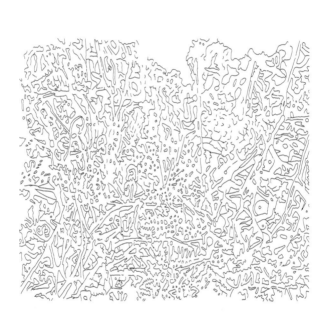

imagined they beheld in them.

In the mid 1940s Ernst moved to Arizona where he built a house with his wife, Dorothea Tanning. The barren Sedona desert, fantastically primeval and pre-human, would have recaptured the decalcomanic visions that had been percolating through the picture planes of his mind. The embroidered threads of copper-gold porphyry in rich red soils, the pink agate crystals ringing against marble and malachite, and the glistening azurite at the edges of collapsed calderas – all would have made their mark on his imagination. Tapping into his own shamanistic persona, and aided by the surrounding landscape, he sublimated these dreamscapes-as-mythologies back into his paintings. And it was after exposure to this otherworldly space that Ernst painted some of his most febrile and nebulous landscapes: *Europe after the Rain II*, *Napoleon in the Wilderness*, *Summer Night in Arizona* and *The Eye of Silence*. In these key works the traditional vector of fossilisation is reversed so that minerals are transformed into living creatures. In *The Eye of Silence* a fossilised temple, flame-lit and decorated with tropical birds, is poised in anticipation of a metamorphic ritual. Its lithic keepers remain camouflaged beneath lichens and liverworts humming with mineral life. Archaean moulds and chloroplastic casts paint eukaryotic messages with bacterial spray. Petrified trees morph into bejewelled bodies. The forest's

twinkling third eye – a purple glowing omphalous – is embedded in an Egyptian pylon. Each new viewing brings with it a new taxonomy of species, both known and unknown. Kangaroo rats and pocket mice. Lungfish and dung beetles. A twisted assemblage of nematodes and rotifers. Xenobiotic secretions create baroque extrusions of hydra-like limbs. Goldfish, koi, and red-eared sliders create abstract ideograms and send telegrams to their future bodies. Freakish taloned roots claw at the substrata while rhizomes funnel ichor back to the lowest reaches of this petrified planet. And what of those liquid prisms condensed onto bodies, are they not the Promethean droplets each animal is awaiting? Like the visions found in figured stones, here is an endless stream of half-forgotten dreams and hypnogogic impressions that rise and cycle through the seams and sediments. Postcards of canyons and mesas sent back to us from dream journeys into the western lands of the mind.

Ernst's technique invited chaos to play a role in the creative act. By opening the door to chance he invited nature to play a dominant role. This mirrors Chinese landscape painting wherein the artist *becomes* the nature they intend to describe – acting as a conduit to its invisible forces. Chaos, paradoxically then, is an ordering principle, as only out of an indeterminate mess can any coherent landscape emerge. The workings of the imagination finds its own pertinent analogies to the

workings of geology in the bio-mineral continuum of form-making. And, like Ernst, we must become geological to receive our visions. Visions that develop with the accumulative stigmergy of impressions made through reinforcement or erasure; accretions and attritions of the subconscious strata. By freeing our imagination to embellish chaos in this way we re-enact those processes on earth and assist in an emergent system of image-making. Decalcomania is the perfect perceptual model for processing our own epic vistas from the unpredictable agglomerations in rock.[10] Worlds are weathered into shape from features that are, themselves, weathered by nature into rock.

The mimetic excess of these worlds sometimes verges on the orgiastic; a self-devouring mimesis, where rocks become animals and ruins become human. Everything is in a state of metamorphosis, commuting through phase states. The casting of bodies into stone propagates a connective panpsychic forcefield through the animal, vegetable and mineral kingdoms. It glues them into a single substance to recapitulate the old idea of earth as an exotic fertile body that gives birth to all things, living or inanimate.

Among the confusion of animals in Ernst's paintings, one is worth singling out. He is well known to lithic scryers and a famed captive of many rocks. He returns in many guises, this boundary communicator of the liminal

zone, this secret agent of the lithotropos – totem of viscosity, guardian of viscidity, spy as friend. Once his avian form had nested firmly in Ernst's psyche, he began to be seen hiding everywhere. An emissary of Thoth, inscrutable and glass-eyed. A master transcoder of all human thought. His Saturnian glare sucks in the whole universe, such is his gargantuan thirst for human knowledge. Ernst called this spirit bird 'Loplop', and for the artist he became a symbol of transference: a Jungian condensation of the artist's own alter ego in totemic form. And as the signals the artist received from this bird became more vivid, and the mythology grew, so Loplop eventually became the sole executioner of Ernst's deepest psychological dealings. Distilled from the textural abstractions of his paintings, Ernst's avian avatars would spy on him from their fossilised nests. Tiny tropical birds would flock like floaters across the lens of his eye and act as auguries for future paintings. The murmurations of their migratory arrows gliding through the crystal pools of the viscous humour. The gods we weave into our personal mythologies take on lives of their own, and we meet them face to face in the visions we cast into rocks. Our chimeras wait with the patience of time itself to ferry our deepest secrets back from the far side of deep time.

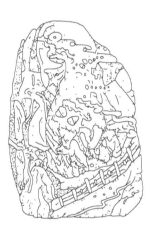

Bloodstones (The Walled City of Changhua)

With blood-red flecks and arterial systems, Changhua
stones, also known as bloodstones, offer to the eye a
potent pathology of lithos. In these stones it seems that
the very body of the earth has been cut open to reveal a
scheme of bloody diatremes – a spread of vivid streaks
pouring through the earth's cadaver. Inside rock capil-
laries, the streaks of red form a freckled sluice that leaks
across the bruised-peach blurs of cytoplasmic urges and
into the thirsts of metamorphic veins. If the ragged clefts
in Taihu stones suggest the forms of ancient bones, and
the fissured curves of Anhui rocks the shapes of ravaged
skulls, then Changhua stones propose the frozen flow of
earth-born ichor.

Red in rock has forever symbolised blood, and blood
in rock enlivens the idea of the earth as a living, dead *or*
mythic body. In ancient Rome red-flecked stones were
worn as amulets to stem the loss of blood. In India they
were used to staunch a bleeding wound when impressed
upon the skin.[11] The Incas believed that the blood of their
gods flowed through precious stones,[12] and for medieval
Christians the stains of red in stone symbolised drops of
blood from their saviour's crucifixion.

Bloodstone, another name for heliotrope, gets its
speckled red from smears of haematite embedded in the
stone. This oxide shares its etymology with haemoglobin,

the molecule that transports iron through the living veins of every animal. And so it seems that geology is pre-disposed to reciprocate the strategies of biology. In the forking veins of planar fractures, and with the texture of an ancient flow long-ceased, lithic blood courses through the earth's hepatic portals to create its own anatomical designs. Thermal forces distil the lithic plasma through thin-veined walls to reservoirs of crack-sealed space where that colluvia accumulates. A seepage that, in turn, turns stars within the earth's unconscious sediments.[13]

In ancient China, bloodstone was carved into sacred seals which, when impressed upon strips of bamboo, created glistening characters with a waxy sheen. This 'blood writing' can be traced back more than three thousand years to when it was used to write prognostications on oracles of bone. On scapulas and on the shells of turtles a magic writing came to life and signed the way to more complex scripts which were then transferred to stones.

The designs of hand-carved bloodstone can be *so* arresting that even the most questing eye sacrifices all other interests and forgoes all other stimuli to peruse the details. Lavish curves and sculpted waves suggest the forms of chambered hearts and ornamental lairs with streams of fractal smoke. Carved lines trace spiral-bound paths and swirled inflections hinting at some delirious internal logic – the carver's hand invoked by unseen forces which emanate from within the rock. An artistry

guided by the divinity of blood to accentuate geology's inner solicitations. Bloodstone was commonly carved into elaborate scenes and ornate landscapes: tiny villages hanging from precipices amid vast promontories. Often, animals would also haunt these scenes, especially birds and dragons. And according to a legend it was a golden pheasant that spilt its blood upon a mountain after being bitten by a snake – its blood flowing into the veins of rock to infuse it with that trademark bloody flair.[14]

Red lights in southern skies. Dream cell necropoli of flame-forged visions awaken memories of flushed horizons. Inside a bloodstone, smoke is billowing across the sky. Specular lines of half-forgotten paths thread their way through rock to a sleeping city where sun-baked walls feed clinging vines that twine their stems through Lycian tombs. The walled city of Changhua is a blurred mirage hanging in a bloodshot haze. The sun, a half-closed eye, recedes behind the city's walls – suspended like a melting jewel over russet brickwork. And as it moves to safety in falling light it leaves behind an emblem of its herald: an ancient shiny beetle that rolls another different, smaller sun along its path. The city, now a blackened crystal, folds its shadows inwards. Moonlight spills through the cracks in mortar, projecting maps upon the quartz-encrusted rubble. Eyes glitter with a green spark in the streets below, before the city retires to sleep. Flares criss-cross and cross-hatch the city's

archive as ley lines light up for returning spirits. Cerise and copper holding patterns hang their emblems skywards – runways cleared for long-haul spectres returning from their wild-fire dreams.

The narratives of bloodstone unfold in numerous permutations. Blurred outlines diffuse to scenes of minarets and silhouettes of colonnades. Dreaming lines draw the skyward-pointing arrows of sun-stoked pylons. Plan upon plan, dream upon dream, layered images reveal the compound lines of mounds and tombs and mausoleums – a Fata Morgana of ancient towns made into a single reddened city and arranged according to the rules of geomancy. Here and there, shadows race across the squares and plazas – shadows hatched as ghosted zones on breathing maps. Figures exhale their wreaths of rock-cut spells in damask smoke. A rubescent trail to catch a current and to connect all dreams. A sign to mark a place of dreaming; a beacon for the dreaming space. A script to score the ember fever; a shift from rock to living fire.

The crimson finch flies east, the red-veined darter, west. The sierra newt and scarlet ibis ignore the movements of the magnet. All reds lead to the stellar mansions of ghosts and corpses, to where the night has become a captive to the tender tint of dawn, and to where dreams dissolve to scattered rust. Red mites have traced their final lines and formed their final runes. The cardinal has inscribed, in flight, the terminating circle.

Today, nothing much remains of the famous scenes of fired-up glory; mining has destroyed the ruby palaces and collapsed the city's towers. The ground has sunk, the city's walls are ruined and the motherlodes are empty. All that is left of the temples are their outlines marked in stone. Nature's teeming generosity has been reduced and levelled to a plane of ruins; only faint inscriptions recall the former glory of the famous walled city of Changhua.

Wenstones

To the untrained eye, it may be impossible to say whether certain rocks were carved alone by natural forces or whether some human hand had intervened. Such is the precision of certain Lingbi 'Wen' stones, whose considered forms seem to be the work of a master sculptor and not the result of some capricious river current. Like classical busts they direct their glance from an age diverted, with a look of pure vorticist intent. These drunken satyrs of the cubist cycle peer out from rock like stolen sentinels: captives of time, captives of stone. And, Janus headed, they seem to look at time from both directions. Perhaps nature had set the tone and left instructions for a now-absent master carver, for it seems incredible that water alone could fashion such well-proportioned curves and evocative features. These stones grant us the refined proportions of Greco-Roman busts with the (con) fused vitriol of some angular and vortical distortion. Like ancient robot heads with precision curves, their forms transpose the vertices of antiquity into a future world. Here is Epstein's visored *Rock Drill*: a mnemonic and a memory – but a memory of what? In its harsh lines and gouged-out features we sense the motions of the forgotten motors. From behind its eyes we can faintly hear a vault of machine-like sounds and the clanking of ancestral systems. Upon the floor, arranged around it,

are some fractured wheels and other relics, and, in the centre of that solemn circle, a cenote throws light upon the shards of fossil cyborgs. Geology, as a future provocation, can be a warning of our future fate.

Cavernstones

> 'The nethermost caverns are not for the fathoming of eyes that see;
> for their marvels are strange and terrific ... things have learnt to
> walk that ought to crawl.'[15]

H.P. Lovecraft

Some stones are so porous and pitted that they invite
the curious eye to wander deep into their secret spaces.
For below their outer crusts you will find an elaborate
network of mines and crypts with worn and wasted
bedrock riddled with holes and strewn with scaffold-
ings of rock. Runnels furrow through their seams and
ferry silt back through their channels. Here is a place of
slow tunnel-building akin to neural network growth: a
brain-like subterrain of branching chutes and boreholes.
Here are the truncated synapses of the earth's own cortex
lacing through the sediments of deep time. Channels
chisel thoughts and then smooth them into memories.
And, here and there, the ducts link limbs to form larger
chambers within the stony matrix. Uncertain tunnels
weave past vaults, past chimneys, past domes and past
concavities crammed with towers scratched with touch-
stone signs. Water writes its paean to gravity as it finds
its new affinities. So, scored within this rock, we have
another proof of Newton's inverse. Another computation
worked within the rock, another winding sum of liquid

flow, and another fluid thread to guide the eyeless. We float beyond these flooded channels, past barques and caravels of ghosts, and past chambers clogged with bones and piled with feathers.

Drunken – in both a nightmare and in a dream – we have reached the legendary 'caverns measureless to man'.[16] We have reached the fathomless lairs of the unconscious world where the veins of gems and precious metals are withheld. Gold, silver and sapphire refract the forgotten indices of the roving mind back into lucid signs. Geology and alchemy have been set alight and polarised. The geodes of the mind are tuned, the sigils of the conscious will, aligned. And then a teasing light leads us on towards a vault of hanging prisms that refract the light into a thousand dancing points. Meandering with a swirling motion, these moving stars subdivide the curve of space. Geology transmutes to geodesy as the point-cloud confirms a holographic fantasy. We see a fountain and a dome with five thousand tiny cells, each unique and honeycombed. We have found the crystal hall of Albaicín and above our heads its eight pendentives arc around us.[17]

There is a certain Anhui stone so full of holes that it is probably more air than substance. It weighs almost nothing and is as delicate as foam. Its medusal nest of tubes seems devised according to some inverse-knotted string theory. So many different portals abound on its

surface but each one leads to a single common sanctum – an inner core of perpetual dream and sleep. Except that it is not sleep, but a state of pre-life which consumes that dark interior. This is a place of the body unformed, a place of pre-existence. And the urge to leave this place is the urge to be renewed. To escape this tomb of rock we must become the initiate who enters the cave to be reborn. And *that* escape symbolises the primal act of becoming human, because the cave plays double to the womb. To early humans the glimmering light that flickered on the walls of caves traced the embryonic glyphs of early writing. The dancing lights that drifted through those ancient minds were the portents of the foetal thoughts that were yet to find their meaning.

There is a horror in certain caves that may invoke insanity – a pandemonium of meditations upon endless lairs and ceaseless tubes.[18] It is the madness that comes to inflict those who inhabit underground cities. It is the mania of the Morlocks and it is the Cimmerian curse.[19] Psychoanalytic readings tell us that tunnel-phobia unleashes a feverish paranoia as its monsters burrow deep into the unconscious mind, creating fissures and fractures the lead towards a total psychic breakdown. Fear multiplies through these claustrophobic pores like a metastasising contagion. The miles of empty tunnels may map the shape of fear spreading through the brain itself. The ancient books on alchemy tell of serpents who

roamed such tunnels of the imagination, their chthonic energies were tamed to ciphers and scored to pages. Certain codices mention gems found in caves formed from the spit of such monsters. So, the glistening stones that lay along these tortuous paths – that may seem alluring – are but the signs of our own inverted thoughts, disguised. There is a rock whose tunnels twist and turn, riddling towards a secret centre where an ancient fossil can be found entombed within a crust of scolded metal. Beside it lays a cemented pituitary gland (the philosophers' stone). The broken mainline brainstem has found its deadline tomb.

If we peer into the frozen heart of stone we might see the eyeless Proteus – the keeper of the cave and the holder of the clew – that spidery ball of liquid thread that guides the eyeless through Anhui's lightless labyrinth.[20] Denizens of the dark internal, get thee onwards! Bring to us the Tatzelwurm and the wingless insects. For here, below the crust, darkness mutes these creatures' growth and disturbs their evolution. Feelers lengthen and wings grow stunted as hormones reel within the pitch-black void. Switched off from light (and switched off from time) they live extended lives in their eternal stasis. Of all the creatures of the karst topographies, it was the Tatzelwurm that terrified more than any other as it slith-ered through the landscapes of the psyche and embedded itself within the porous sleep of lucid dreams. The 'tunnel

worm', with its cat-like face and serpent's body, could kill
at distance with the poison of its breath alone.

The incunabula of the imagination is consistent with
the ecology of nature. Thoughts route through the con-
scious mind like tree roots breaking through the earth.
Tenebrous thought-trains rumble through tunnels and
cruise through portals. Imagination is shunted along its
tracks by tectonic jolts causing the darkest visions to run
free inside the lithic consciousness. Shifting images settle
into the common stream of the collective unconscious,
reconfiguring and refining their forms by addition and
erasure, like the methods of geology.

As part of the occult respiratory system of the earth,
caves enjoy their own hermetic microclimates. And being
so tenuously tuned to the world above, only the rarest
squalls can disturb their meditations. In their coldest
reaches ice may form and conform to strange configura-
tions; a florescent hoar-frost that encrusts the rock with
glistening needles. A field of glassy growths to bring a
burst of constellations. Bubbles, captive in their upward
glancing paths, withhold their precious cargoes. Folds
of ice form perfect peristyles and colonnades. And all
around the crystal clubs and branching trunks enclose a
hyperborean fantasy: a verglas temple pegged with spikes
of ice, and with waves of frost that never seem to break
upon its hearth. Here, in this silent space, temperature
replaces time as a useful referent of delineation.

This sinter world is full of lucent growths and leached formations of a dark seclusion. Dripstone forms cascades in complex casts, like folded fabric or moulded beeswax. Frills of lime flow down in waves, rolling over cracks and rifts and hanging over lips of rock. Flowstone twists and bends into bulbous manifolds and humpbacked trolls. Strange creatures swim through the fields of crystal needles. Every imagined phantom is ramified inside this calcite cortex. Every creature ever dreamed of flits within its cold, uneven walls. Here is a macabre frieze of a twisted spinal marrow, where the tendons of *Trophonius* are stretched tight by frozen hooks of ice; where wax-work walls reveal Lovecraftian sarcophagi with cephalopods entombed within their siliceous membranes. Here the magma of mind has cooled its twisted thoughts into basilisks and frozen griffins, and from every angle wet limbs appear protruding and multiplying. A brace of fractal Kalis hangs from folds of poisoned flower flesh, with their bloodied scythes in hand. Cave cosmology commutes to sonography as the black goddess intones her *kāla* cycles.[21] But in this stolen centre there are no living things with ears to hear these brooding rumbles. They are for the earth, herself, to hear alone.

Here is a cave of brains melded into a single module. A mass of axons moulded by the endless drips of time. Smooth grooves and gouged-out lines run across the earthed *callosum*: its lobe and gyrus feed the liquids to a

core where dreams are stratified and stored. And in the deepest fissures of this limestone cortex the empty nodes of flintoid space work their charms upon the fluids, drip by drip, dream by dream, into vague and half-formed scenes. Gorged on spurs of frozen gore, the images pour through vessels and towards that central calcite synapse where each drip forms another fragment until a perfect image of the world is realised, and the workings of the black reaction returns its final image to the recess of the dream cell.

Helictites dangle like parasites trussed round pivots – their viral forms promoting misplaced beauty. Like strains of *spirochaetes* made of stone, they spike into the psyche of the cave to prime their routes and mine their paths to ports of darkened memory. Karst topography is pure pathology of thinking, where steps of sinter cascade their trains of thought. Here is a terrace of diminished repetitions of a logic made in scaled dimensions. And within the seams, the marbled lime divides the lines of thought, and the calcite brain is left to precipitate its ruminations. Sanity and substance converge into a single mass as thoughts take shape within the neural maze. If these caves in stone suggest the meshes of the brain, then they also mimic those other systems of the body. Their tubes become the twisting innards and inner syphons of the lower regions. Karst topography is pure pathology, both of the mind and of the body.

Mirrorstones

In the *Stone Catalogue of Cloudy Forest*, Tu Wan recalls 'a splendid black-blue stone, several feet broad, standing by the mountainside that reflects objects from considerable distance'.[22] He notes that there is a similar reflecting stone at a place called Lin-an-Lsien. According to sinologist Edward H. Schafer, Liu Yuan wrote of this latter stone in his *Preface of the Stone Speculum* stating that 'such natural mirrors are not uncommon but have provoked disquiet among observers'. Here, he refers to those who see within their shining surfaces spirits, demons and lurking apparitions. Chinese lore abounds with stories of mirrorstones that have supernatural powers and certain rocks said to be so polished that every detail of a human face could be seen reflected in them. A reflected portrait that might contain some deeper essence of a truer – or even darker – self.

When the child repeats the mantra 'who am I, who am I, who am I' before the mirror, they attempt to separate the image of the body from their inner self.[23] Those early reflections upon such separations tell them that the body is not the self and that a mirror may show them things beyond their sensed perception. Similarly, a scrying mirror when peered upon within a darkened room may connect us with the characters of our unseen selves. Mirrorstones convert our image into the face of

providence – they become our lustrous oracles by pre-
dicting fates and reflecting futures. By inverting bodies
and transmuting our sense of self, they translate the
psyche into something visible, something reachable, and
therefore something readable. And, like a deck of tarot
cards, they grant us access to those submerged urges we
secretly devise for ourselves.

Of all the tales of reflective stones in Chinese lore,
one sheds more light than any other on the meta-
physics of the mirror. The story concerns a group of
stones located near Lake Kung-t'ing, a flood basin of
the Yangtze River (known in Chinese literature for its
submerged cavern ruled by spirits).[24] We are told that, on
stumbling upon this pile of gleaming stones, a trespasser
puts a flame to one and chars it; and, as if in spite, the
heavens blind him and dull the other stones. According
to the natural moral law, mirrorstones are deemed to
be the eyes of earth and are set in strict accord with
human eyes so that sight and stone are fused into a single
sympathy. If one is dulled by unkindly acts, the other one
must surely follow. In the Tao of the landscape, nature
is all-seeing and so impossible to fool. Mirrorstones
are, therefore, the watchers of our actions and they may
be called upon as witnesses to weigh our deeds at any
moment. The metaphysics of the mirror presupposes
an axis of perception that splits the self into its truthful
double – a double who might be held accountable for the

actions of its twin. And it is for this reason that mirrored rooms have long been used to witness rituals, oversee agreements and to watch the signing of important treatises. Nothing can be hidden within the Sheesh Mahal, nor forgotten in the palaces of mirrors.

Mirrorstones contrive to mimic all the instruments that augment the eye to repeat the laws of optics – from the skeins of spiders to the gleaming tigers' eyes, from shining crystals to the lattices of light that illuminate each plane of purpose. Mirrorstones gather light and then subdivide it. They melt the image and return it as the *mage*. They break the landscape into molten shapes and return it as a perfect mirage. They unfold the code of chiral order to prime the mind for the symmetries of nature.

The silver snakes have glazed our eyes with chromium. The gods have churned themselves into a carousel of sylphs. In distorted waves the animals appear from within the shining cyclorama – the phoenix and the Chinese fox, the silkworm and the eight-forked serpent. In the uneven polished surfaces of these stones light is serviced with all it needs to create a perfect metal bestiary. Rock concavities pull the rays of light into backward-shining stars that collapse beyond the limestone limits. Fake entrances appear to lead the eye to yet more unknown ports of aberration.

In some specular repose nature writes its reflected fantasy in these natural mirrored halls so that it can

flaunt a vision of another way of seeing. In the sheening nebulae of ray-traced shapes, geology presents to us, in all its spatial permutations, an image of how the world *could* be.

In mirrorstones what was fixed becomes protean. Images shift in confounding combinations, distorting the conventions of rational perception – returning phantasms of what is imagined beyond the boundary surface of the self. Our mutable being is given form by the magnetic flow-lines of the specular; a visage of the self forged into a paragon of the fantastic or ideal.

The word 'mirror' comes from the Latin *mirare*, which means 'to look at' and 'to admire'. That root is still used today in Spanish (*mirar*, 'to look'). The word 'miracle' shares a similar root – the Latin *miraculum* means 'object of wonder' or 'that which causes astonishment'. To reflect upon something is to think something through and to meditate upon it. A focus that renders an image of a problem more clearly in the mind. We go inwards (and petition to our mirror double) to gain lucidity so that we may shed some light on the essence of a thing.

Chimestones, Talking Stones

Sonorous stones – rocks that ring their supernatural
tones. Ashen-white Lingbi stones, coralesque and mon-
olithic, strain their lingering metal tones back towards
some prehistoric resonance. Their corroded inflections
sound out the emptiness of scooped-out space. Erosion
has turned its hand to making instruments, carving
stones into sounding boxes with weathered ventricles
as vocal chambers. Mimetic rocks ping ghost messages
to far-off mountain spirits with thin timbres that float
across the landscape. Hollow tones enshrine the moun-
tain peaks and shift their pitch according to the misted
density. Sonorous stones act as atmospheric pressure
gauges sounding out the local microclimates.

So prized were lithophones for their pure and mysti-
cal tones that officials of the imperial orchestras ordered
local magistrates to embark upon large-scale searches for
the most perfect-sounding stones. Jadeite was quarried
and then shaved into slithers of 'echo slabs' – thin slices
of green or pale-blue rock sometimes said to mimic the
sound of humans singing. Circles of suspended jade were
set to intone the ancient song-texts, harmonising the
world to the scale of aeons – their voices, with a prosodic
pealing, weighing out the syllables of time.

In his treatise on the Confucian ceremony, the
'second sage' Mencius remarked that 'music begins

with the sound of bronze bells and ends with that of the jadeite chime'.[25] Mencius locates a reciprocity between Confucian lore and the ringing sound of jade and he suggests that *only* these stones can mark the end of a Confucian ceremony and bring to it the purest harmony. The search for perfect stones improved the existing knowledge of surrounding geography, and as new territories were scrutinised the symbolism of the Confucian cosmos was transposed back onto the landscape by association. The search consecrated new and unknown lands into Confucian cosmological space. Jade, as a symbol of the heavenly virtues, became the binding material between the physical and metaphysical domains. And so the search for chimes transferred a conception of heaven back onto earth.

By the sixteenth century, ranked officials were appointed to scour the little known – and then mythical – region of Xinjiang for seams of Nephrite jade.[26] It took months to find the stones and years to complete the sets of L-shaped chimes that were used in solstice ceremonies. In Confucian lore the centred tones of jadeite chimes were said to synchronise the entire cosmos. They were thought to harmonise the territories and tune society. And so the symbolism of the singing stones would conflate the Confucian cosmos with mysteries of the distant Xinjiang province in a ritual affirmation. Weathered boulders, broken into pieces, spilled the jade into the

surrounding landscape. Rivers carried these spilt extractions – as scattered condensates of Confucian lore – into the land. With this mapping of the regions – granted by the prospecting for ceremonial tones – sound, stone and place became entwined within a single immutable cosmology.

There are certain Lingbi stones said to sound like human voices, and strange chatterings can be heard from within them. And, like their *visual* counterparts – the transforming clouds and shifting inkblots – these stones may return a stream of words to answer calls and fulfil our wishes. What is heard are fragment-words part-birthed and semi-comprehended, like those half-formed words heard at the blurred edge of sleep (the hypnogogic voices that shoal through the mind). Larger stones were said to reflect the sounds of neighbour stones and set a space for an otherworldly conversation. Sounds from great distances were captured in concavities and then rebounded back through space to create a gallery of whispers, blending bird and insect calls. Filamentous voices transported on a wing, rounding contours, sculpting space and humming secret invocations, as indistinct as whistling wind or the waves that crash on distant beaches. Voices in stone abound in Chinese folklore.[27] They arise from the belief that rocks are sentient and geology exists within the greater conscious matrix, acting as an agent for otherwise untransmittable messages.

Singing stones are the vocal parts of higher beings and the mouthpieces of the unseen gods.

A Little History of Lithophilia

In the seventh century, the poet Bai Juyi takes his daily stroll around famed Lake Tai and his eye is caught by a pair of rocks protruding in a bay. Their eccentric forms seem to him to be alive and beg for his attention. In their craggy shapes he sees limbs and torsos and – though strange and grotesque – these rocks appear to him as human. 'Can you keep company with an old man like myself', he writes to them in his now-famous poem. This meeting of a form of lithic conviviality sets the tone for rock collecting and marks the beginning of the era of their veneration.

Two hundred years later, in the garden of an administrative precinct, Mi Fu bows ceremoniously to his favoured Elder Brother Rock instead of paying all due respect to the assembled dignitaries at his ministerial induction. His veneration to the rock is offered in ways germane to a member of official rank, and in doing this he mocks official status. The performance becomes consigned to legend and the story of Mi Fu and his Elder Brother Rock becomes a theme for painters whose later works celebrate the famous scene. Paintings depict Mi Fu imitating rock. His craggy facial contours mimic time-worn boulders and even his clothes assimilate the hard lines and shadows of his elder brother's form. Late in life, Mi Fu became known for his wistful landscape paintings

and for his facetious retorts to all convention. Such was his addiction to, and endless quest for, suggestive rocks that he earned the appellation 'Crazy Mi'. His collections and his fastidious annotations on the qualities of rocks provoked a new surge in rock collecting. From this time onwards, stones were mounted on carved hardwood plinths and placed in rooms. Bound within the liminality of contemplation the rocks began to take on living forms. They began create an inter-zone for the imagination to correlate them with their spirit doubles.

Around the time of the Song Dynasty the popularity of Lake Tai stones began to wane in favour of much darker glassy Lingbi stones made popular by emperor Huizong. His biomorphic rocks were so prized that they were given names and inscribed with gold calligraphy. Rocks resembling birds, animals, and demonic forms were collected from the furthest reaches of the province. Solemn figures stood in gardens, their countenances frozen within the cryptic seams of time – each a messenger from the earth's unconscious underside. And, by some providential twist of fate, Huizong's destiny was written in his amassed collection. In a desire to quench his unabated thirst for stones he dismantled bridges to allow his boats to bring him increasing mounds of rocks and stones. So obsessed was he with such a seemingly surreal addiction that his eye was turned from the invading Jurchen nomads who set his fate by using his precious

rocks as fodder for their catapults. In a twist that would seem to mock any fiction, poor Huizong's collection was used against him. And not just his empire was lost but his entire rock collection, which to him was more precious than any universe – a different kind of empire clearly more dear to him.

TIME COMPILED

In contemplating rocks we must shift the miniature
gears of our watches to cycles of such magnitude that the
seconds now seem to move so slowly as to appear not to
move at all. Geological time, a paradox of both stasis and
immense unending movement, encapsulates *all* time, and
for this reason it has the assured anonymity of oblivion.
Rocks tell us that time is a thing intangible but yet fatal,
something invisible yet vivid and with such a devastating
effect. Yet, in the presence of the two, it is the author-
ity of time that becomes uncertain – for only against
the grave durations of geology can time's true mettle be
judged. Geology makes time take stock of itself – it is
the only thing that can give time any sense of certainty.
Take away the aeons and the eras, the Archeans and the

Hadeans, remove the periods and epochs, the Cambrians
and the Silurians, and you will see that there really is
no time. Geology is so obdurate in this respect that the
only way *it* can exist is by the clever trick of flowing
through itself (while remaining fixed like water). Geology
suspends time but it also moulds it, pushing it to near
breaking point. This interplay with time in rock has been
traditionally appreciated, so much so that all around the
world there are collectors of certain stones who assure
themselves of great longevity just by being in proxim-
ity with their beloved pieces. Here is a world of rooms
with rocks and people suspended in their vortices of
time-just-stopped.

Rocks condense time by converging their immensi-
ties upon our small cycles. They compile the aeons and
– bearing witness to the vast dimensions of the stellar
constellations – they condense all orogenic complexi-
ties into a single glance. Timescales break into pieces
when the textural promiscuity of rocks is beamed to the
eye. The Eocene crumples, the Milocene cracks and the
Pleistocene zooms towards us. By reaching deep into
our imaginations a rock momentarily relinquishes its
place in oblivion and, enmeshed within the spectres of
our fascinations, it connects to *our* time. Momentarily
it remains captive to *our* sense of space before pressing
onwards into the empty distance. Rocks may peer across
eternities but in their solemn stillness they bring to us

an essence of a moment when the eye of time cast its
clearest and most untainted vision – an impression cast
upon the mizzen shroud of perpetuity, where the vaguest
hints of some future port of call are given. Here are the
glimmers of an Archaean proposition firing forwards to
its future destination – towards celestial navigation and
radiometric dating.

With the discovery of *deep time* the Scottish geologist
James Hutton unbracketed geology from its sure sense
of belonging and absolved it from any sense of origin.[28]
When he stared in awe at Siccar Point his eyes drew a
blank and his mind reeled backwards to a time both
unfathomable and unknowable – a time ripped up from
its rails. In Hutton's own immortal words, geology had
'no vestige of a beginning, no prospect of an end'.[29] Until
this point, time had been bound by theological dimen-
sions, fixed in place by the doctrines of religion.[30] It was
Hutton's friend John Playfair who remarked upon this
new-found heresy that 'the mind seemed to grow giddy
by looking so far into the abyss'.[31] No wonder that theol-
ogy was so appalled with deep time, which held within
itself connotations of an ancient world of dark and som-
bre spirits. The path to Eden now seemed to trace back to
an abyss devoid of any temporal referent, a place of devils
and hell-bound demons.

In their perfect garden labyrinths made of stone,
the artisans of the Ming-Qing era rebuilt the cosmos on

an earthly scale and conceived of it as a timeless place. By multiplying space with a maze-like repetition, their gardens confounded any sense of standard temporal flow. The word 'labyrinth' can be translated into Chinese as *migong*, which means 'a perplexing palace'.[32] And these perplexing palaces were aimed at elevating one's experience beyond that of the earthly world to a time suspended, a time held forever in an instant – the Blakeian *time deferred*. This absolute, non-reducible time can be separated from the mythic concept of eternity as the Heideggerian 'original' time which leads to the 'ecstases' of temporality.

Figured stones connect human time with this primordial time. They imply both Heraclitus's *axiom of mutability* (the coursing flux of flowing time) and Parmenides's *eternal stasis of our being* (the 'all time' of the single glance). Figured stones mock our quests of becoming by evoking the *ecstasis* of being. And, in the ecstasy of time where our becoming *is* our being, we become like a rock – static within the instant, equipoised and immune to entropy, a cosmic dot without a measurement of movement.

Yet, perhaps a rock is not so much an emblem of these hard-to-grasp eternities but an emblem of eternity's own forgetfulness – or its slow realisation of what it really is. A rock, as a fragment of earth's own memory, only recollects itself in the presence of *a* consciousness

that can perceive it, because nothing else exists in time's forgetfulness, not even the stars who must await *our* invented fates. Time *is* stern, but it takes a mortal to transmogrify its work into a thing with living spirit. Only a soul that dies can transform a thing that lasts forever, with a spell or with a vision, into something conscious. And so, as *memento mori* (or the inverted signs of death) rocks may symbolise our mortal struggles but they also breathe life into our immortal souls. In the company of rocks we create parity between our transience and that essential emptiness of unceasing durations.

Stones confound our mental ordering of time by reducing it to a convergent instant that calls up memories of our early ancestors who fixed their conscious will upon their stones. And so rocks become the mnemonic aides for the unravelling of this atavistic memory. They sign the paths to our early psychic states. In their company we can connect with all the lives that came before us, and so the scryer of geology is a commuter through the ancestral chains.

Geology provokes the mind to forgo its grip on time as a thing falsely envisioned, frequently imprisoned, and so often commodified. It returns to us a time of state-less liberty; a Gaussian blur devoid of any fixity. When we gaze into a rock we become as old as the earth itself. Figured stones, then, are alms to break the capital's hegemony on temporality. The scryer of geology gains a

special sensed perception through prolonged reflection, because any form of sustained interrogation becomes a meditation upon the paradox of time.

Fleeting impressions held in rock, a hundred thousand years of metamorphic resonance. In just a single stone, all the echelons are displayed before us; all true evidence of the timeless gods were laid bare to see. The evidence is strong: with enough time eventually everything will happen and *only* geology will be its witness.

ALGORITHMS & MANIFOLDS

Erosion never takes time to rest and the sharp edges of
some irregular rocks finally become so rounded as to
suggest the complex forms of an algorithmic ornament:
the crystalline structures of Byzantine geology, razed
from a Gothic Atlantis. Scaled, worn and scraped, these
wrecked architectons of nature have been iterated beyond
all ordinary dimensionality into mathematical carica-
tures of their former shapes. Flow coefficients sculpt
the stones into volumetric forms with twisted planes
and exotic surfaces. A few accrue the forms of miniature
terrains with spike-like growths. Palaces and palisades
reside within their minuscule Balinese dimensions.
Occasionally microorganisms have been allowed to col-
laborate in the micro-city's spread. The turvy topocosm

of minute terraces creates subspaces within this Garden of Eden configuration.[33] Iterative mosses map their territories over cubo-futurist facades in irregular tessellations. Bacterial colonies create radial diffusions. The rippling force of water has created tiny mountain peaks and fanning alluvial terrains. Dendritic spines elongate to form miniature skyscrapers, but the isometric view is compacted into a fractal flatland – an urban sprawl of structures locked in place with precise space-filling intelligence. Proliferating textures imply a drama of multiplicities – the building of cities, emergent structures and self-organising systems.

These mineralogical models of a reductive infinity are prized by mathematicians as much as they are by metaphysicians. Pancomputationalists (and object-oriented geologists) have seen these calculations in stone before – they know their shapes by heart.[34] They see in each rock a single archetype – a seed or prototype for the invocation of any kind of rock. They see in each rock a single calculation from that larger program. Of course, nature has its own peculiar whims in computing forms that mimic its greater features and often makes 'mistakes'. Computations stutter and generate momentary glitches in nature's own rendering system. Corrupted iterations output exotic reproductions. Nature has no thirst for the ideals of perfection. It adds nothing nor takes anything from its programs and its conditionals

are never at fault. Each imperfection is a secret intention
and a clever ruse.

MORBID FASCINATIONS

There is no censorship in the society of the imagination.
Our collective visions are curated according to the whims
of our inner dispositions. So, while the literature on
figured stones and scholar's rocks is devoted to images of
an idyllic reception, little has been said about the shadow
worlds that lurk within their crevices and the skulls and
skeletons that haunt their outlines. There are certain
rocks capable of transmitting a corpus of morbid fascina-
tions, where dark forces transpose miniature Edens into
ossified objects of decay and deformity. The once-mossy
sylvan forests have become graveyards of bones and
sinister forms. Jagged textures profile contorted skulls
and bony distortions of disastrous proportions. Mangled
bones copulate in ritualistic Yab-Yum, crashing together

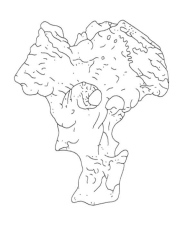

in a tectonic frenzy. Necrotic idols run riot, dream-
ing of demons and bubbling bones. Rocks churn their
demented forms, mutating through minds like demons
on fire.

A contorted eye socket forms the hollowed-out gaze
of a cyclopean monster blinded by time to the nebulous
underworld of misshapen crags that mirror its own
skeletal deformities. The eye socket is a black hole – an
obsidian sphere that draws into its space all things that
are living. These terrifying malformations in stone hail
the syndrome of Proteus, the shape-shifting affliction
that converts all sublimity of human form into a dark
mass of maddening protrusions. Smooth rock drips into
pleats of dehydrated flesh: black Mahakalas await their
barques to funeral pyres and hermaphrodites assume the
burnt-out forms of blow-torched aliens. These petrified
biomorphs have rendered the human form a grotesque
glyph – a bony question mark that stares back into the
face of genetics. Or else their conglomerations sign
nefarious spells and bad omens – the black, billow-
ing clouds of nuclear fall-out, or an unholy trinity of
metastasising bone, bubbling magma and petrified dust.
The ornately carved plinths on which these rocks stand
only further amplify the austere guise of their studied
pose. Their mutations (surprisingly congruous with the
delicately worked rosewood) frame them as Giacometti-
esque maquettes, emaciated but defiant in their

indifference. These triumphant Lovecraftian trophies celebrate the delights of the after-flesh. They summon the lost ghosts of Baudelaire and Poe.

Nature has offered to us natural *memento mori*, gifting to us votive forms as objects upon which to meditate on our impermanence. By persisting long after our demise, these rocks tease us by bringing into focus our fleeting existence. But they also grant us access to another kind of immortality. While deep time has reduced our lives to insignificant spans it has also given us totems to usher us back towards an expansive eternity. For to wander through the desolate territories of these stones is to wander through our own deaths, while still alive. All stones, having seen the human generations come and go, have absorbed the full spectra of life and the complete span of death.

There is a certain Lingbi stone whose form perfectly mimics a ravaged skull. Eye sockets are distended and the cheek bones deformed. Thumb marks of an unnamed sculptor remain impressed upon the bone, the malicious, or careless, impressions left by a clumsy creator. But look a little closer. Are there not the faintest glimmers of life smouldering from within those darkened orbs? Though no light escapes their event horizons, a spirit burns deep within them. Mere mention of Aztec marigold transforms this muddled shape into La Catrina, Lady Death, the 'dapper skull' of the Day of the Dead.

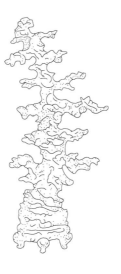

She's eyeing us up with a toothless grin – a protolithic smirk that spreads across her hollow face, and in amused concentration she channels the words of the dead, adding their oratories to her death scroll with a pen made from bone. Whispered, spittle-drenched words form dark clouds which condense into carbonised signs (a language that breaks and falls into ashes). These are the hollow speech bubbles of the fossil-fuel apocalypse. And just as a stream of candle smoke reveals the direction of an imperceptible breeze, these drifting cartouches are a herald of something terrible and frightening: the gaseous emanations that carouse through our disturbed imaginations, precipitating voids with premonitions of burnt gods and disfigured effigies. Her orisons turn bone to dust and infect the brain with the scolded residue of panic. When she laughs there is a dry rasping sound like the carapaces of beetles being rubbed together. Nagging us with her solicitations, she decrees the forms of fevers and the manias of nightmares.

In life Catrina elegantly roamed the upper classes, but death has stripped her bare of social status. Reduced to bone she shows us that death inevitably brings its neutralising force to all, rich or poor. Similarly, figured rocks have provoked Taoists to meditate on the nature of impermanence. For these skulls of stone foreshadow the timelessness of our bones against their fleeting time in flesh, and mirror our eventual fate. Skulls have formed

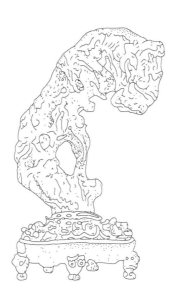

their own substratum within the collective unconscious by becoming a dominant symbol within a larger matrix of apotropaic magic. Bejewelled, they have been used to avert the chthonic forces and when tied into necklaces may even symbolise a victory over time itself.

The lakes of the Anhui province are full of such skull stones. Each lake has its own particular economy for a geology of mortality. Limestone terraces embedded with skulls create sub-aquatic amphitheatres for departed souls and deported deities. Liquid graveyards and occasional crypts await the fearless diver. Beacon skulls mark richer seams – the motherlodes of an eerie Atlantean charnel ground. But time fixes not a thing in place, and even after they are raised from their watery nightmare and placed on plinths these skulls of stone continue their onward journeys through time to be further eroded by the human gaze. Like clouds constantly transforming they forever evade fixed form. Even death has its own kind of impermanence.

There are other stones from the Lingbi province that present yet more strange mistakes of physiognomy. There is one well-known stone mounted upon a Suzhou-style base that swings a clubbed foot from its elephantine leg. Its left arm is muscular but the right arm is withered, and instead of fingers both 'hands' have pincers. But make no mistake, this is no crustacean. This mishap of biology is Rodin's *The Thinker* in embryonic form

– transformed from an image of contemplation into a figure of thoughtlessness. Where there should be a head there is now only a fist. Its axons are petrified, its neurons have ossified. Here, encephalised rock has displaced the marble index of the mind. Its thoughtlessness is proportional only to its formlessness. But somehow, despite its cruel and contorted form, there is an elegance to its design just the same. Nature cannot make an ugly thing, and for now we must suspend judgement and accept that this convulsive beauty holds not a few sublime secrets from the stratified sagas of the previous ages.

THE LION GROVE

Taihu rocks, so named because they are found around, or within, Lake Tai, are a paragon of all the figured stones. They have been collected, sketched and celebrated more than any other kind of rock. If you were to choose just a single specimen to emblematise the spirit of figured stones it would be a stone from Lake Tai. Furrowed and jagged, and famous for its pits and void-like apertures, the lake proved so popular during the age of great collecting that it was almost emptied. Rocks were even brought from other regions and immersed within its waters, as if to be nourished by its spirit and moulded by its propitious currents. Years later these rocks were retrieved and brought back to shore, but only after their shapes had assumed the classic curves of ripples, waves

and frozen spume. These monolithic rocks, which can be up to fifty feet in height, were carved from submerged limestone beds and raised by divers. They were then brought ashore and positioned as sentries to guard over groves and gardens. Their baroque outlines threw complex shadows across the earth, soft-curved shapes containing a dozen half-moon cuts to confuse the light. Off-white bone-like stelæ, finished by long-forgotten currents, cut their cloud-like silhouettes across the sky. Some geologists have suggested that Lake Tai was formed by a meteoric impact.[35] Its sediments have thrown up quartz-rich shards and shatter cones – the signatures of fallen stars and fiery bolides. If true, then Tahui rocks may owe their shapes as much to meteors as they do to terrestrial causes.

To linger upon these complex stones is to merge within their forms and to move within their thin and glairy networks. To meditate upon their grain is to steer through skeins of shell-like space and to trace siliceous silhouettes of ghosted shapes. We watched the lithic veins sketch bone equations. We saw the contours migrate to the tips of coalescent limbs. We beheld the drifts of tiny protists that saw their colonies diffuse through space, we read these rocks as charts and maps of lunar cycles.

Lifelong loves are often seeded from a single chance encounter. So it was for Bai Juyi, who, being enamoured by the timeless shapes of Lake Tai stones, composed his

famous poem in which he asked that these rocks might
be his friends.[36] Bai Juyi continued to write poems about
the Taihu rocks he found on his daily rambles and often
talked of them as if they were his relatives. He took
solace in their ageless forms and they gave him comfort
in his final years. His enthusiasm for Lake Tai stones and
the elegies he wrote to them achieved fame throughout
his lifetime. So began the great age of collecting Taihu
rocks and the trend for their veneration that is still alive
today. In the literature on rock aesthetics Mi Fu (of Elder
Brother Rock fame)[37] coined the term 'Tou' to describe
the character of Taihu rocks – a character that with time
became regarded as the most desired aesthetic quality in
all the figured stones. Tou evoked the empty-full dichot-
omy that binds the world. It symbolised the play of void
and form that pervades the universe. It evoked the space
where *form takes place*. It is the Buddhist *form as empti-
ness* and *emptiness as form*.

The famous rock gardens of Suzhou, located in the
Eastern coastal province of Jiangsu, contain some of
the finest, as well as many of the largest, Taihu stones
in China. Its Lion Grove is home to a complex maze
of jagged limestone figures that guard its paths and
watch over its pavilions. The Grove is especially marked
with massive monoliths; rocks metamorphosed from
coral, brought from ancient seas onto reclaimed land
and then weathered into a daunting profusion of wild

configurations. Large angular rocks congregate in the likeness of lions and other animals. Comic sprites stand in suspended animation. Biomorphic look-outs keep watch over the networks of bridges that thread their way across narrow channels and lead to islands of yet more stone characters. And as the eye plots its way through these mimetic gorges and cascades of rock it is guided by the strange attractions of uncertain configurations; small hints are disclosed to the inquisitive eye by the enticing shapes. And in tracing out these clues from the rocky cavalcades of stone the eye draws a complex path within its field of view – an unseen script is written behind the eye and mapped to memory so that the images pulled from these palisades of rock are checked and matched against the inner store. And from these rumours aroused by rock a tale unfolds of haunts and lairs. Eyes stare back and glimmer with the unglazed tint of time itself. Fractured shadows tease out hidden phantoms from the living textures of the breathing rock. Like Pollock's drips of paint, the logic of these forms only reveals itself through prolonged reflection.

Lion Grove is a stage that confounds all attempt at serious contemplation, for it is a place where geology shifts its focus from monstrosity to mad comedy. One glance may bring to us a gang of demons, the next resolves the scene to troupes of trolls.

Tunnels worm their way through jumbled forms,

their systems multiplied in pools and ponds. Ripples reflect the water's caustic patterns onto grotto walls as dancing sprites. In secluded courtyards with latticed windows even stranger rocks reside. Circular doorways and cut-out portals frame complex biomorphic shapes. Limestone pieces pinned to walls appear as fossil paintings. In sealed-off spaces larger stones intone their silent measurements of time. There is a sense of something brooding in the silence and a numinous latency implied. What occurs within these sanctuaries when there are no human eyes to watch, pry and measure any temporal difference?

The spirits which reside within us create the animals we hope to see. So the grove finds its characters mirrored from our inner references and fashioned by our own fixations. Unconscious rumblings tumble through the limestone strata and become enlivened. What we believe in, we begin to see; and what we begin to see we start to worship *or* begin to fear.

Shapeshifting – as the oldest form of totemic magic – evokes a range of complex themes and causes. Though traditionally confined to humans, the Lion Grove extends *that* morphing force to include the facets of geology. So, did the animals of Lion Grove choose their destiny to gain a port of entry or did they shift their forms to escape an enemy? *Or* were they cast to stone by spells as punishment for some unknown crime? The curse of

petrification may find its root in a curious affliction.
Calcinosis brings a hardening of the heart valves and a
slow stiffening of the muscles. Some animals succumb to
this misery by ingesting devil's figs or yellow oat grass.[38]
Though many years may pass without a symptom, these
animals gradually turn to stone. Only the most enliv-
ening imagination could hope to reanimate them from
their frozen casements.

The history of Lion Grove is as broken as the rocks
that make it. And, like any other history, it is a history
eroded, or made, by lore and legend. The grove has fallen
into so many cycles of disrepair and renovation that the
process itself seems almost geological. Repeatedly re-in-
voked upon pre-existing plans and brought to life fol-
lowing times of political strife, the grove is a palimpsest
revised by time and rewritten by the rocks that form it.
Though new features have been added, and refinements
made, its underlying configuration remains the same.
Constrained by extant designs its changes have followed
the pattern of a spared intention: a narrative conforming
to the requests of the land. Like so many gardens, Lion
Grove has a mind of its own and, wherever apparent,
human intervention has lent to it the most transparent of
touches.

The grove originated in the twelfth century when
Buddhist monk Wen Tianru began its construction as
a homage to his teacher.[39] After his death the garden

was revised and developed as a puzzling labyrinth to be enjoyed by local scholars. Its maze-like plan was emblematic of a more playful philosophy that displaced the austerities of the philosophy of Zen.[40] Scholars of the later Qing dynasty would roam its rebus and compose special verses in its honour. They saw the grove as a condensation of the entire cosmos and its navigation would come to symbolise the Taoist path towards perfection. The experience of the maze, then, became a sublimation of the Taoist way and the trail towards the truthful self. But though the grove may guide us towards some common destination it also writes a story unique to every one of us, so that the animals we perceive when wandering through its paths suggest the private traits of our own inward journey. And as with any maze, it positions us as pilgrims navigating the metaphysics of the spatial realm. The labyrinth of the Lion Grove is a machine to aid transcendence.

Here and there, inscriptions on the stones consolidate poetic and emotive allusions. Doorway carvings proclaim the Taoist tenets to fortify the garden's potency by creating a parallel mythology and a microcosmic analogy. The gardens and their rocks all have literary allusions, commonly recalling the names of the poets who wrote elegies inspired by the garden's beauty.

Words written in awe of Suzhou often aimed at reproducing its visible virtues on the page. And those

verses sought a kind of perfection, for poetry was seen
as an echo-form of the sensations gleaned from obser-
vation. Nature's self-awareness, as exemplified by its
knack for mimicry, would be personified in lyrics. A
perfect poem would aim to erase all aspects of the human
in its replication of the natural world, and that perfect
poem could be returned in spirit to the treatises made on
gardening. So, garden, rock and poem were all refined
towards a spiritual beauty according to the tenets of
Taoist law. Such was the popularity of these gardens as
heavenly archetypes that many remained as elaborate
vagaries in the minds of poets. The appropriately named
'Garden of Almost-Being-There', conceived by scholar
Huang Zhouxing, was the most famous fantasy garden
that never existed.[41] Though elaborate plans were drawn
up for the garden it remained unbuilt, existing only as a
testament to the imagination, and of an idea of the heav-
enly brought to earth.

If the shapeshifting rocks of Lion Grove prohibit any
fixity of image then they also deny any normal sense of
time. Like a primeval forest the Grove exists outside of
time because it does not have to endure a chronology.
Even after we have departed from the Grove its appari-
tions remain vivid in our minds, continuing to work their
magic and impress us with their prescience. The figures
of the Grove colonise our psyches and settle in our mem-
ories – we may leave *their* place, but they remain *within*

us. Now it is our job to continue working with these ghosts in stone that roam our minds.

Every gardener fulfils the urge for mimicry as a kind of cosmic imitation for every garden is a microcosm of the greater world. Gardeners gain sustenance from nature by echoing its character, a transposition of the greater world into a tiny corner that becomes a model for a way of seeing and a system for a way of being. In the laboratory of the garden an agreement is made between inner spirit and outer world. And within that implicit contract the act of doing becomes the binding will – and in that dialogue we divine a special kind of knowledge.

FOUND EMOTIONS

Comparisons to the figures seen in Lion Grove may be
found in the gardens and landscaped follies built by
'outsider' artists. They can be seen too in 'found objects'
transformed into sculptural oddities. In his series, the
Little Statues of Precarious Life, Jean Dubuffet trans-
formed discarded objects into grotesque busts that were
both humorous and unsettling. In one work, *Tête Barbue*,
we find a stump of washed-up driftwood clustered
with a tangled mess of knots. The prying eyes of some
as-yet-unnamed ghost protrude from within its furrowed
brow. Tubes of hair cover every part of its head and join
its beard in a single manifold. Situated on its pedestal,
this creature casts its rotten gaze into the distance. Who
was this being? Who was this anomaly disfigured by

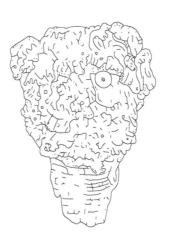

antiquity? The answer to that question lays within the grains of wood that line its face and which project the tracks of so many different storylines (take your pick which track to follow, for all the tales ring true). In another of Dubuffet's works, a sponge-like mass is held upon a wire.[42] This figure stands proud – an armless herald to a future bone-land. A provocateur of freakish myths and grotesque realities, it has a crudity that brings to it a compelling raw austerity.

Found objects offer the mind's eye a blank canvas from which to work upon and, by propositioning the imagination, they set the stage for an enactment of the transfigured gaze. Their proposal is one of a free bargaining with the imagination so that what is meaningful and what has power exists between what is seen and what is imagined. Chance operations can have their way once the erosive forces have run their course. A rock or piece of washed-up wood beholds a face within that fertile, suggestive space of inward-glancing thought.

Erosion has acquired a bewitching magic and the lines of time have deemed these figures invincible to any further degradation. And like the figures of Lion Grove, Dubuffet's works suggest the heraldry of busts and beasts from bygone ages. They stand as aberrant figures of Greek and Roman myths. But time has contrived to impart a kind of anti-monumentality to their image to bridge a gap between the ideals of form and the majesty

of ruins. Imperfections and malformations bring to them a willed deformity. By emphasising elements of caricature through crudeness Dubuffet's sculptures are allied with the transcendental power of the corrosive forces. Like figured stones they behave as projective visionary devices for beings both terrifying and amusing. Dubuffet added little to his found objects to avoid any corruption of their vital spirit. For him, the human hand was cursed by centuries of cultural indoctrination and any intervention would wield a death-blow to such untainted essence. He saw the found object as an antidote to conditioned culture and the sterile baggage that travelled with it.

The artisans of figured stones saw no harm in embellishing their rocks *as long as* the vital 'laws of nature' were not revoked. Authenticity, for them, was transmutable but not reducible. Nature could be encouraged but not invented. Sometimes rocks were glued together to create hybrid forms. Imperfect stones were improved upon, suggesting that nature's work had been left unfinished. Rocks of different types were placed in crevices of much larger rocks, proposing trees and shrubs in diminutive vistas. Incense sticks added soft streams of smoke to these hazy scenes. But despite such modifications the artisans always steered towards some kind of authenticity.[43] However much they prostheticised their rocks, they aimed to strike natural balance – a *natural* selection of an aesthetic kind which honed the rocks

towards a preconceived perfection while obliging to the natural laws. Pitted rocks with 'pellet nests' and 'rain-indents' became the norm – a natural-beautific raised from the underbelly of a Frankensteinian invention.

The found object – the rock or piece of washed-up wood – is an expression of a form of hylozoic seepage; a consciousness that moulds its shapes. Nature's urge to communicate its phantom 'thoughts' through washed-up husks and rocks seems to be an inherent force, and strength, of evolution. As found objects, they become found emotions and, by extension, can offer found solutions. They tender a profound experience where 'art' can become indistinct from the earth itself. Figured stones and scholar's rocks are nature's offerings to the greater canon of raw 'outsider art'.

ERRATIC WORSHIP

Stone erratics. Transcending time, eclipsing distance. Shipwrecked monoliths that sail across the empty landscape. As natural markers and ports of call, they have been worshipped as loci of divine power since time immemorial. They have formed the focal points for human wonder and wish fulfilment. And being untethered from their place of origin, they are a kind of pilgrim – commuting across the ancient byways and migrating from ancestral grounds of stone. The root of 'erratic' is in the Latin *errare* which means to wander. As they wander through the immensities of time and space these giant rocks become witnesses to the earth's internal monologues. They are the eavesdroppers of the sediments.

The earliest forms of any kind of veneration were tied to mountains and fetishes found in stone: the devil's tower, the eye of silence, the perfect holding stone. Erratics forge their place in time by merging with our myths and merging with our wishes. Unbeknown auguries of futures to be wished for and the venerable seeds of superstitions. As enigmatic comments made upon the landscape it is only natural that erratics would arouse suspicion and be interpreted as auspicious signs. Incongruous and suggestive, they invoke the possibility of a deeper, richer narrative in an otherwise empty landscape. As tricks played by the earth they solicit decipherment, and so it is inevitable that the agency of their magic would be ascribed to the actions of beings with divine power or incredible strength – entities demanding both respect and reverence, and whose potency would ferment with time as the stone accretes power through the successive layering of a directed veneration. Questions about these rocks' provenance would – and still does – appeal to the curious. Who, or what, could have balanced them in such a precarious manner, held aloft to the heavens on pedestals and revelling in their conspicuous prominence?

Erratics have been called, variously, 'intruders' and 'wandered-rocks', indicating their propensity for arriving, seemingly uninvited, from some distant or exotic location. They have also been called 'giant's throws',

alluding to the folkloric idea – common around the world – that they were launched by mythological beings into their unlikely configurations. Their improbable locations insinuate the work of a superhuman force. A force that must somehow, still, be stored within these rock's substance. There are old photographs from the late-nineteenth century depicting adults and children standing next to huge erratics, posing as Lilliputians to reconfirm geology's power to expand our imaginations while simultaneously reducing our size.

In certain myths surrounding erratics the spirit *of* the rock and the spirit *contained within* the rock become conflated (another property of our projective entanglement with geology). Rocks gain a voice and act as intermediaries to the distant gods of a remote spirit world. They become transmission devices in the cargo cult of geology. Legend and lore get locked into them. Morals and mores precipitate into their substance like some slow paragenetic process of mineral formation: rocks suffused with the sophisticated outpouring of human consciousness; physical symbols of a place in the mind dedicated to spiritual appeasement; deification as kind of metamorphism.

CONSCIOUS STONES

In the extended field of perception, where spirit and
matter fuse into a single stream, figured stones are
the objects of an all-embracing and deeply connected
hylozoic consciousness. They are a locus for our active
imaginations to perceive geology with the significance
of a thing that seems alive – a thing that permeates
thinking, animates the memory, and enlivens the spirit.
Given the potential for this fecundity between the human
and mineral domains, should we include rocks among
the things we define as conscious and living? The answer
to this question relies on upon our ability to modify the
status of differentiation we have set up for the mineral
world because, perhaps, only by *unhumanising* ourselves
(to use a term borrowed from the poet Robinson Jeffers)

can we begin to resituate human consciousness within a reach that includes geology. By looking beyond the reductionism of 'just materiality', we can begin to understand something of the earth's desires as it communicates to us through the landscapes it has devised to speak its language. If we give rocks the opportunity to speak to us then we allow them to become characters that can act upon the psychophysical stage. By becoming what Jeffers called 'not-human', we can tune in to *their* hidden intentions and become guests to *their* proclivities.

In his essay 'Ojibwa Ontology, Behavior, and World View', anthropologist Alfred Irving Hallowell observes that the Ojibwa, an Indigenous People of North America, do not categorise 'objects' like stones as *inert*. Rather, they allow that stones may possess 'animate properties of a "higher" order'. A stone might be singled out for a specific morphological trait, its propensity for mimicry or for having a 'voice'. In so doing it becomes a focus for causality – a trigger for events in the wider universe or an emblem of auspicious synchrony. By according rocks 'animate' potentiality, the Ojibwa world view stands in opposition to the dualism of Cartesian thought and the distinction between mind and matter – that crux of western ontology. In a not dissimilar way, in Taoism and Buddhism *every* rock contains a consciousness comparable to our own. It is a consciousness that is deemed

to flow through all phenomena, and is best understood, and experienced, through contemplation and by the fine-tuning of the awareness of *that* practice.

Old Taoist manuals on the planning of rock gardens describe rocks as having their own personalities and frequently mention the notion of 'following the request of the rock'.[44] Rocks may be like needy children, or crafty like old cantankerous monks. They may request recognition or beg for attention. They may ask that their wishes be fulfilled in order to obviate any chance of bad luck. Rocks were given nicknames, 'master rock,' 'demon rock,' and 'rock of vengeful spirits'. These humorous appellations belied the degree to which each stone was seen to be alive with a personality. Once a name was given the seed was sewn and the character began to take on a life of its own. Conversations with stones would cement their reputation and metamorphose their character. To understand such a sophisticated experience requires a leap beyond that well-worn reductionist way of thinking. The two-way communication between animate and inanimate is full of emergent signs and the more present we are within its ecology of symbols the more fluent we become with its language and the more alive that language seems to be. Both Taoists and Indigenous cultures have developed sophisticated languages with which to deal with this connection, enabling them to speak with their 'living' stones.

Dualist thinking permitted science to obviate the 'spirit world' of geology, replacing it with observations about the chemistry and age of the Earth. It erased the divinity of nature by turning perception towards the purely phenomenological (constrained by a reductionist approach). It lead to the foundation of the geosciences but also, more disastrously, to a way of thinking that saw the planet as a resource which could be broken into pieces and sold. It subdued the idea of the 'living earth' with the concept of 'just matter' – a subjugation that slowed the infusion of myth with the presence of the inanimate. Romanticism was a bold attempt to revive the image of the living earth as a reaction to the doom of the Industrial Revolution. Hermetic schools, too, traditionally erred towards a preservation of the hylozoic stance and aimed in their methods to confirm the idea of transmutability between spirit and matter. The Romantic sciences proved to be the final bastion of defence against the virulence of the dualism that would come to dominate our current era. If Hermeticists believed that geology possessed an awareness, it was because they knew rocks were the most truthful witnesses of time. By attempting to unlock a consciousness held within the deep-time of geology, they hoped to access an awareness contained within their rocks. But by the mid-nineteenth century the last waves of Romanticism had been forced into a woeful submission and the bond between the spirit

and the mineral world was finally broken. The concept of a resonant 'world soul' or *anima mundi* was consigned to oblivion. Cartesian thinking, from then on, saw animism as an error which only rationality could cure.

Our perceptions have been so indoctrinated by the reductionist stance that all other ways of thinking are today deemed inferior. Collecting and meditating upon rocks, then, is not only a testament to another way of thinking but it also offers protection against the limitations of reductive thinking. Geological scrying offers shielding against a way of seeing that unnecessarily dissects the idea of consciousness into meaningless parts – a stance that has alienated us from the earth, and distanced us from ourselves. A distanced consciousness *will* want to revolt, and *visionary geology* provides the perfect stage for that revolution to play out on. A hylozoic ontology defends the imagination from the self-censoring that is at the core of the Cartesian approach, and can offer renewal for the disconnected, disenfranchised spirit.

As found objects of power, stones have been collected for as long as there have been eyes to desire them. Encountered in charged places or during auspicious moments, they have been taken from beaches, from forests and from deserts. A stone may be selected for its shape or for its colour. It may resemble a familiar object or an animal, a demon or a god. A stone may contain a favourable quality associated with a propitious

event. It may be embellished with a magical sign or transformed into a talisman. The transferral of spirit into rocks is found in all shamanic cultures, and in certain tribal practices it forms part of a larger matrix of magic, divination and initiation. The otā stones of the Candomblé, a cult in Brazil, have so much agency that they must be hidden from sight in special shrines.[45] In darkness they accrue power as invisible objects of the highest veneration. The cult believes that a stone *asks* to be found and that its providence awaits human contact. A voice heard in the stone, then, is a solicitation from the earth, an attempt to make contact. Once selected, a process is set in place which leads to the steady layering (totemisation) of embodied desire into the stone. Magical intention transforms it into something with magical agency. The Candomblé believes a hidden stone gains power through its invisibility and by the lingering connotation of its veiled presence (stones are consecrated with prayers before being hidden in darkness). Neither the Candomblé not Taoists fix their stones as static objects but instead imbue them with a dynamic power of presence that is multiplied daily by the stone's living aspect. Agency is bestowed through word projection, and from emanations at an unconscious level. The personality of a stone becomes nurtured by those unconscious vectors as the shadow-self transacts with the rock's own willing shadow. When a spirit is given to a rock, the rock

rebounds that offering. While the Candomblé hide their stones, Taoists have traditionally mounted their stones on delicately carved hardwood plinths, thereby engaging in a transmutable adoration of the visible. Wood-working becomes a conspicuous manifestation of their veneration – another kind of prayer offered.

By granting a spirit to rock we can diffuse into geology's essence. We can be like Flaubert's St. Anthony, who wished to become pure matter in order to *feel how it feels* and *think what it thinks*. Flaubert developed his character in order to explore the metempsychosis of materiality as transmitted through geology. Through St. Anthony, Flaubert intuits the visions born from rock as an encoding of a maker and the ciphers of a god. In the cliffs all around him, Anthony see strange figures – the inventors of auguries dividing the sky and the outlines of sphinxes. He sees the beasts of fantastical myth. He sees basilisks and unicorns, and he witnesses strange cloud formations which resolve into the figures of gods. And what these chimera tell him is no less as fantastic than their appearance, because he finds that these visions can only breed yet more visions. Chimerical panpsychism is a hallucinatory drug of endless self-perpetuation. If the landforms seem alive it is because Anthony's perception breathed life into them.

THE EROSION OF WORDS

The language of geology is resonant with poetic connotation and suggestive allusion, and its terminology contains apt metaphors to evoke the workings of the mind. Words too, it seems, by some mutuality, subscribe to the whims of geology and, like rocks, they become weathered by use and polished by time. Sometimes that erosion is so great that what remains of a word may only be an essence of what it once was; an attrition so drastic and so complete as to render the word unrecognisable. It has become a *word erratic* – a stranger from its place of provenance. But as with rocks, even erratic words find a point of fixity and a moment of equilibrium when their meanings hold shape to resist the onward flow. So the evolution a word is a geology of processes.

Writing is another kind of weathering – an invocation worn to intoned form and then conferred to text. And just as water needs to find the path of least resistance, so writing is the finding of that simple form. So, how to write in a way that evokes the crags and scarps and the broken shapes of rocks? With sentences as bare as bone, or with lines of broken texture? Can a style of writing approach the geology it attempts to describe with voids, fissures and fractured shapes, or with soft, round curves and rhythmic structures? Wandering through the combined space of language and geology, we pass the fossil words and bones of etymology. And while we leave our trails of thoughts as dotted palimpsests upon the page, so geology and writing merge with the earth's own fractured memory to become its own palaeography. For the earth's memory is another kind of text written to the landscape – its recollections reduced to traces and scored in lines that mark the land.

Sentences gleaned from rocks and then their words returned as charms – rewritten to the land, remapped to well-walked paths. A trail of words returned as footprints, a chain of lengthy footnotes. A shorthand for a way of thinking; a place for words to remake the world anew. Visions born between the inner world and the outer prospect, and the page as screen between the two. What is written upon that page sets the future course of flow as the images move beyond their vague terrains

to leave their trace. They unravel like a river behind our eyes, their impressions floating beyond our reach to direct the habits of our as-yet-unfixed memories. And they bring their charms from far-off places and drop their spells upon the mounds and folds of language. Totem words and marker words, and words that wait to be unearthed. Words as sigils and words as curses to bend all meanings from their course.

Like the images we see in clouds or rocks, these words – and their meanings – are always shifting, until something new appears; and then something new appears, again. A simple vision worn to memory as memory is worn to stone. But the vanished image always leaves its trace – an essence that fortifies an absence to confirm a presence. The ghosted word remains.

The images that drift behind our open eyes are the images born from inward-glancing memories. And if we scrutinise those images, they seem so vague as if to not exist at all. Memory, like the void in a stone, is given form by something solid (the written word). The landscape, likewise, makes its point by persisting in the field of vision, and by touching something deep within us to consign a prefiguration of its imputations into psychic space. Our myths leech back and forth through sediments, and memory brings its own deposits to those seams. And in collaboration they seem to relinquish any sense of origin in that amorphous space of inconsistent

shapes that we try to capture upon the page.

We walk a land invoked from these ghosted words and worded imprints. We walk that spare and steady path. And what we know of place is best derived not from images but from words, for images belie a fixed perspective whereas words encompass every aspect.

And if writing is erosion, then reading is erosion too – a perceptual sculpting of the written form, interpreted to fit our expectations as the words succumb to the demands of our requests.

THE GEOLOGY OF DREAMS

Carl Jung viewed the body as an archive, a 'museum of organs [...] with a long evolutionary history behind them'.[46] Though evolution had improved the body and refined its features, older essences remained, both as a metaphor and physical manifestation. In extension, he believed that there were 'living fossil structures (buried) in the psyche', remnants of earlier psychological situations concealed within the archives of older conscious states. For Jung the psyche was a stratification of partially discarded detritus; a place of the fragmentary remains of an evolving mind embedded in the seams of psychohistory. And if he was able to become an archaeologist of the inner self and excavate these artefacts, he would be able to piece together the fragments of the

larger archive. The latent symbolism of this procedure precipitated its way back into Jung's own psyche, eventually revealing itself to him in greater detail in a dream – a dream which was to become the focus of his most important idea, and one which he recalled and revised for the rest of his life. Its remembering was for Jung a way of unlocking hidden meaning, and its refinement, through a process of accretion, was itself geological. In the dream, Jung descends through the floors of a house where each floor resembles a different period in culture. The uppermost room, which is full of paintings and the trappings of high culture, represents Jung's own era, and on the lower floors he discovers a room of Greco-Roman statues which he realises represents the foundation of civilisation. Descending even further he finally reaches the lowest level which resembles a cave or a tomb. There, half embedded in dust, he see the skulls and skeletons of two prehistoric people alongside pieces of broken pottery – a potent symbolic representation of the place of the birth of human consciousness and a reference to the time when the burying of our psychological urges may first have began.

Jung's descent – from the uppermost floor down to the cave – unlocks for him the discovery of the *collective unconscious* (it is important that the location of the unconscious, here, is found through descent). The dream gained legendary traction during Jung's lifetime and he

continued to mine its meanings for the rest of his life. But it required the terminology of geology to fully frame its symbolism. The unearthing of the hidden layers of the psyche becomes a geological quest (in mythology, *the hero's quest*).[47] What remains of our past, and what clues us to our futures, exists as a code embedded as (index) fossils of the psyche. Figured stones allow us to re-enact this excavatory process by unearthing artefacts buried in our own psychic sediments, and by throwing light upon their meanings by association.

The symbology of Jung's stratification of consciousness (which he extracted by analysing the metaphors contained within his dream) may lead to the problematic ascription to prehistoric people of 'primal' forms of cognition. Since then, the error of that conclusion has been foregrounded in numerous works of archaeology and anthropology. We now know that Jung's 'prehistoric people' were as mentally sophisticated as we are, and that the conditions of their tools were not indicative of their mental finesse. Despite this, Jung's dream image remains pertinent through its use of geological metaphor as a way of approaching the structure (and the historicity) of consciousness, as well as being a strong metaphor for the layered concealment of an 'unconscious seam' which contains a treasure of psychical artefacts. More importantly, we can use Jung's acknowledgement of his reworking of his dream as an entry point to a method for

applying geological processes to dream analysis.

In recounting dreams, we reformulate their narratives and shape them into their most honest and truest form. Dream re-visioning can be seen as a geological process where indistinct images are weathered into fixity by rational attrition. Dreams find their narrative equilibrium first through their remembering and then by their recounting to oneself. This unravelling of narrative is a process of form-finding, like a river finding a shortest path or a rock being worn smooth by flowing water. It is like the gradual shaping and refinement of a tale to fit the requirements of a myth that it encodes. The shifting collage of dream imagery – a visage of an intense, decalcomanic complexity – becomes anchored by the cues of the rational mind (like the fixing of a photographic image where vague shrouds slowly reveal sharper edges). This anchoring of the dream image is like a vision crystallising from the texture of a stone.

Figured stones, then, are keys to our dream assemblages because their broken and capricious forms reflect the weathering of our dreamed impression by our wakened consciousness. They become the windows into our unconscious depths because they have parity with the phantoms of the psyche. The images that come to us in dreams are interchangeable but they are vitrified and given solidity through connectivity and correlation. It is in the poetry of free association that dreams are

understood, where some sense is made from the inner cinema of rootless chaos. Rocks and stones clue us to the allusions hidden in dreams, and it is for that reason that they have been used as oracles and aides for dream divination. This mutuality between geology as a reading of the psyche and the psyche as reading of geology vindicates the world as a self-inductive system (with its poesies of reciprocity). If the psyche can be modelled on geology, then perhaps geology is another kind of dreaming performed by earth. And, as Max Ernst knew all too well; when the earth dreams, it dreams of exotic planetary landscapes spanning forgotten eras, with vistas crammed full of of seemingly unfathomable syntax. The images we see in rocks are an ideographic shorthand of the layerings in dreams (and the detritus we find in our dream excavations clue us to the bond between collective cultural deposits and the personal artefacts we bury). The visions we see in rocks guide us to rich lodes schemed within the structure of a layered *lithomythos*.

By revising his dream throughout his life, and by furnishing it with additional material, Jung retro-fitted his dream to suit the purpose of his theory. It is a powerful image of psychoanalytic self-reflexivity, wherein the geological attrition of the rational mind wears upon a dream – a dream which is itself a geological model of the psyche. In symbolic nested form it is the archetype of archetypes. Once the fully matured dream became

re-stratified as part of Jung's own personal mythology, it became the founding dream for an entire school of psychoanalytic logic – a constructor function for an entire class of dreams based on, and derived from, the principles of geology.[48] In a later essay, Jung calls the lower archetypes 'the chthonic portion of the psyche' and describes them as tangible links to the psychic influence of the earth and the primordial forces of the underworld upon us.[49]

Jung's stratigraphic model of the psyche was based on a uniformly layered historicity, placing the unconscious at the lowest level as 'part of our prehistoric, irrational psychology'. But geological breaks and thrust-faults create discontinuities and many much older bedded planes may appear above much younger ones. Cargoes from different eras of ideation collude. Old myths seep into more recent sediments and resurface as new lores. Materials from previous excavations become reburied and recombined with earlier material so that the muddled seams of psychohistory create their own complexities. Ancient symbols find rekindled agency as they become re-metamorphosed and are pushed back to the surface. Figured stones can connect these discontinuities and become mediators to aid our stratigraphic disentanglements.

Consciousness stratified in the beds of caves, memories consigned to stone. In an amniotic darkness, the

shapes of partly-made-out thoughts are fixed in place and buried. Geology brings the imagination into touch with these embryos of thought, connects us with those primal utterings. Rocks ferry consciousness across thresholds and bring us into contact with our earliest conscious states. Our ancestors added to the world with the things they thought and the artefacts they made. Each stage on the onward human journey left its special traces with the objects embedded in the earth *and* the ideas embedded in the human psyche – the petroglyphs of bisons and the aurochs of the early inklings, the stencilled human hands of expressionistic fever and the sigils of the shaman script born from dark foundations. Our early instincts were scored as psychic states within the belly of the earth and the cave was placed towards the mirror of the mind to become a syphon for all our future wishes.

As the eye wanders over the clefts and scratches we see in rocks, images of a collective memory are loosened: animals etched on walls of caves; the images of the ice-age fauna moving through the ancient dreams, scenes of hunting flowing through the veins of time; and the ancient fears that crystallised into the starkest warnings. To touch the textures of these rocks is to set *our* minds upon the early minds, and, alighted, to bring us close to memories scored in flint and forged in silex. The lowest seams may contain a dusty cave of relics

with its skeletons and broken Palaeolithic tools, with its bootstrapped archetypes and archetypes as tools, but the relics of this golden seam are always pushing up and through to make their presence felt.

Figured stones are the exclamations of a fractious consciousness thrown to the fore from the cryptic seams of earth's own thought-forms. And beyond linking to our oldest archives, how to make sense of geology's intentions written within these rocks? Here and there, there is a discernible order; as if geology intended its secrets to be unlocked and to be distilled, to be mulled over like a psychoanalyst unlocking the symbology of dreams.

VISIONS FROM THE VOID

On page after page in Flaubert's *The Temptation of Saint Anthony* we are presented with teeming processions of mages and monsters, all summed into the imagination by the agitation of geology. Crags cast shadows of distorted bodies – the supernatural avatars of a revealed inner self. Consciousness is carried off by animistic forces and lulled by their strange coercions. St. Anthony's carousel of chimeras parade through his mind like some strange projective light casting etheric shadow forms. An inner cinema reminiscent of Coleridge's or De Quincey's dreams, and as ornate as any Chinese scroll. Anthony sees nymphs and sirens and fugues of cerberi. He sees jinns and the gnostics of the apocalyptic sects. And in his visions of endless citadels he sees streets so long

and infinite that the eye dissolves within their details.
And just as one vision settles – and Anthony has made
his peace with it – another comes to fill its place. 'For
matter to have so much power it must contain a spirit',
he murmurs to himself – a spirit that pulls together
leaves and feathers, boughs and branches, fur and fleece
into a single tissue.[50] He sees gods riding birds, monsters
rocked in palanquins and strange serpents enthroned
in costume. And all these things are installed upon
the pediments of temples transformed from rock. The
world before his eyes is a living script scored in stone. A
monumental frieze breathed into existence where insects
parade themselves as living jewels and bees beat wings
of pulsing ingots. What holy fire could incite such crazed
and mutant visions?

Some artists have been so wooed by St. Anthony's
divine hallucinations that they have tried to fix them onto
canvas. When living in the desert, Max Ernst doubled on
the story as a way of scrying the chaos of the surround-
ing landscape. Guided by his own ghosts he painted *his*
versions of the visions, transposing geology into a living
scape of sprites and spirits. That St. Anthony has been
realised in so many other compelling works is testament
to the story's force of power. Bosch, Dalí and Leonora
Carrington have all attempted to record in visible form
what was seen by Anthony, and what was heard by him,
beyond the veil.

Works of literature abound with references to faces seen in clouds and demons found in rock. In *Moby Dick*, Melville offers to us a short chapter on the subject.[51] The novel is so crammed with cetalogical lore that it is inevitable we should run aground upon such dedications as those to the leviathan seen in starry skies or in the broken bluffs of cliffs. But before we reach this chapter we have already experienced all flavours of the whaler's mania – its madness and its mad bliss. We have been schooled in the strange perceptual anomalies that haunt him as he sails and drifts upon an open void for months on end with nothing more than his own mind to entertain him. Gazing across that abyss of open ocean, staring at the waves for hours, there is no end to the visions that seem to flit in the fin-shaped crests of waves or in the shadows that play below the ocean's surface. Monotony and the gentle lulling of the waves bring images of whales swimming through the lowest regions of his mind. And on dry land, the whale's presence continues ringing; it is seen in the grain of the wood forming barns and houses. His image is so strongly emblazoned within the whaler's mind that it would seem that the very configuration of his neurons is arrayed in the shape of the Cetacean body.

Pareidolic visions port us to our superstitions, and our personal dispositions conjure images to fit our stations. So what we see in rocks and clouds are things

created from our own obsessions. Whalemen may well see whales in cliffs, but others will see see entirely different creatures. And while Dubuffet saw his amusing mocking characters in the discarded scraps he found, Ernst saw birds peering through the textures that he painted. There is a long tradition of artists being seduced this way. Ernst wrote that Piero di Cosimo would sit in deep contemplation of spit-stained walls, and that 'out of these stains he formed equestrian battles, fantastic towns and the most magnificent landscapes'[52] – here, signs of sickness are transformed to scenes of golden grandeur. For Leonardo de Vinci a splash of paint could suggest any scene imaginable, and in stains on walls he saw scenes condensing through their own inflections (to further goad his imagination). In the fractal zoom of texture he found tiny canvases with natural mountain scenes. He writes that staring at rocks can infuse the mind with a lively store of inventive possibilities – and that the memories of these forms might be recalled as starting points for new fantastic paintings.

The writer Danilo Kiš goes a little further and suggests that the visions aroused by rocks and stains can be read as omens and even curses. The main character in his short story *The Encyclopedia of the Dead* foresees his fate in the stains he embellishes upon his apartment walls.[53] The floral patterns and arborescent tracings are later revealed to be a premonition of the metastasising

growths that will eventually kill him. A fate that would come to Kiš himself.

What we see in rocks and stones depends upon our own internalised database: a stock of culturally mediated imagery forged and embellished by personal memory and psychical topography. For Roger Caillois, 'the vision the eye records is always impoverished and uncertain. Imagination fills it with the treasures of memory and knowledge'.[54] So imagination paints its picture by taking hints and filling voids, and by aggregating all the randomness into something visible and ordered. Solid spirits are churned from tumults and the faces of immortals condensed from crags. Geology amplifies our internal hieroglyphic monologues and forms its figures from these earth-born inkblots. First wings then legs appear, and then a body *moves* – an escapee from our mind's own margins moving into shadow light. A fluttering is felt and a muttering is heard, as a body begins to reveal itself inside the light loop. What we see in stones are fragments of our inner worlds, and in the process of creating these apparitions we *become* our visions and we meet ourselves.

STRANGE OFFERINGS

'Nature is the visible Spirit; Spirit is the invisible Nature.' [55]

Friedrich Wilhelm Joseph Schelling

Reading figures found in stones is a game of wild association where the earth does its bidding with our own imaginations. And the images it returns – in mythic correlations – behold the shifting forms that condense before our eyes as psychotropic residues. Desires spoken in the language of geology and visions precipitated through rock: the ergot dreamstone, the stony raven's brew and the tormented rock-born nebulae. All infections of the mind and all inchoate murmurs of spirits half-baked in stone. Figurines spewed from limestone seams and other spurned diffusions. The tangled outpourings of mad and suggestive provocations condensing within the calcite cortex. The architectures of aesthetic contemplation moulded into spires of rock. Geology as

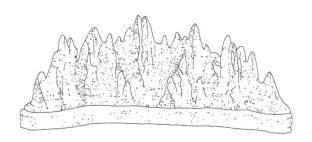

a crazed inducement or expressionistic supplication to hidden gods.

Geology is a visual metaphor of – and mirror to – all our unconscious dealings. With a potency of suggestive possibilities it offers keys to worlds where the real and the imagined are interbred and where our inner worlds blur into the rocky strata of the world before us. Rocks are cryptographic keys to aid decryption; visionary devices for mythic divination. They are the rebuses of our sublimations and the Rosetta Stones for distilling meaning from our hidden predispositions.

When we look at figured stones our eyes skip across their shapes to scan the textures. Lines of sight skim like stones across a lake. Perception flitters as it reads the sectors. Geology, now viewed in random-access mode, is matched against the inner fossil record and images are checked for pattern recognition as the shapes are sorted and the correlations graded. Lithic memory is transferred to human memory; a stratigraphy of precognitions is added to the epigenetic seams. Eidetic figures are etched upon our consciousness and a precious contraband is smuggled into dreams. Figured stones, then, are the outliers of a connective tissue that bridges all forms of consciousness. They create links between different worlds. They are the intermediaries between our conscious mind and our shadow selves.

The parsing of these rock-borne visions to the

eidolons of the mind's own hard drive is like the fixing of an image in a dream at that hazy point of recollection where the image shimmers at the furthest reaches of perception (before it dissipates to the point of becoming only dust or sand) – but *then* comes meaning. Figured stones are an aide-mémoire to all our buried cargo. They are a system for prising evocations from deep within the cryptic contours. Hint by hint and shape by shape, the rocks reveal the earth's own inbound observations. And the broken shapes denote its interjections as the dial-up codes for our terra-psychic conversations.

The most fleeting memory can embellish what is seen in rock with new surprises. The pareidolic gaze may grant us such strange inversions that what once seemed inconsequential now seems a revelation or premonition – obscure impressions become infused with meaning. At the behest of geology, something new is found from something buried.

Through a process of attrition, nature has fashioned stones as strange offerings to the human imagination. With their landscapes, and cloudscapes, and their nebulous writing, these figures in stone bind an arc between our proclivity for pattern recognition and our mythological imagination. They connect us with the collective memory bank of human experience and expose this connection as a higher intention – a gift to us from the earth itself. The gradual transformation of rocks into charms,

and into the guardians of a psychic space, is like the evolution of the sign where chaos is shaped by purpose and made intelligible with charged intent. The things we see in stone have a habit of reflecting the cultural zeitgeist. They become talismans and totems of unnamable urges and the sublimated shapes of our common desires. Our obsessions find shape in their curves and our dreams can be divined from their outlines. The collective imagination is forever being replenished by these offerings from deep time.

Rock reverence invokes a dialogue with our spirit-self and brings to us a precious rendezvous with our own inner voices. It induces a process of ritual objectification and psychic veneration where a spirit *and* intelligence are transferred to an object, moving it beyond 'just materiality' into the realm of sentience, agency and identity. That nature has devised a way to offer these signs and open these channels should be no surprise, for it has also fine-tuned the equipment required to perceive them. The symbiotic flux that occurs between the vision and the object of envisionment (the rock) creates a gradient of consciousness that transcends the conventional boundaries of biology and geology – a diffusion through the bio-mineral community which creates a substrate for visions (and myths). Human consciousness secrets its spectres into stone as geology etches back its spirit into our collective imagination, and as the earth dreams the

landscape into its existence, so we dream its forms back into our world with an abundance of meanings.

Given the impressions they have made upon culture, rocks appear to be among the most conspicuous embodiments of this hylozoic agreement. Perceived with a focused intent they dissolve the dualistic modes of thinking and blur definitions of living and not-living. Within the modern western consciousness, this convergence now only exists as a forgotten trace, submerged and distanced by the imperious disparities forced upon it by the Cartesian approach. But these relics of an ancient way of thinking are perhaps needed more now than ever, for their reification can mediate a kind of restoration and resolution; a trigger for a way of seeing and a *projective re-visioning* of what the future could be. By reflecting our voices back from these stones we can receive guidance and replies to some of our most important questions. Thoughts guided by the geological muse bring about unism and a sharpening of a particular kind of awareness. It leads to stone collecting and rock veneration and it challenges us to read geology as if it were the cause of myths, as it was with St. Anthony, and not merely the stage upon which they were set.

What is beamed from rock to eye often emerges as a ghost of its own intention. Imagination elides what is perceived with what it has projected (so that what is perceived and projected collide into another layer of

meanings). This is the *inter-animating spirit of mind and matter* where biological and mineral kingdoms collude, where their interpenetrating vectors are energised into a single field. Hylozoic resonance has opened a two-way transmission line so that geology can send messages to us in stone. The messages are mineralised into minds and in the marble patterns of neural pathways.

The transcendence of flesh through rock marks a special place in human consciousness. Against the immensity of geological time humans are sublimely insignificant. Paradoxical, then, that this creates a deeper sense of conscious connectivity with a continuum that is beyond human time. It returns us to an undifferentiated, primordial time (placing us at all points along time's endless thread), and to a point in space where no lines exist between each class of thing. But although these stones may seem fixed in the now-and-forever, eventually they too will be erased by the surprises of time. Their figures and phantoms are doomed to be returned to rivers and onwards to oceans, or to be turned into dust for the replenishment of mountains. And pilgrims will be surprised to find the images of their gods, and their scripts, shattered and then reformed in this perpetual cycle of lithic transmigration. This is the constant shuffling of geology and myth through the landscapes that surround us into the landscapes of our imaginations.

Throughout life our bodies are subtracted towards

their final state like stones worn smooth. Through rocks we can learn something of that reduction. Rocks may indulge us in their whims so that we can find our own searched-for dignity.

Some rocks trespass on the consents of the idyllic and gift us with strange confections. They add a darker lexicon to the existing scenic pantheon. Demons and monsters thread their twisted shapes through the lithotropos of the mind. But, all in all, these brooding forms diffuse a lively nightmare of dancing skulls and scorching smiles suffused with life. The soul that drifts through these wrecks of rocky bone and exiled totems is a delighted one, being bathed in the renewing light of such fertile proliferations.

What is to be found beyond the solemn subterfuge of these superficial visions? Perhaps our deep attraction to these phantom forms clue to us something deeper. Psychologists will tell us that we see forms in clouds and stones because our brains evolved visual networks finetuned for survival, and that these shifting illusions are shaped by the rumbling afterglow of a hardwired system that long ago ceased to be a necessity. The networks continue to forge pictures, as if perpetually agitated by the flicker of noise in the unstoppable laboratory of the imagination. But if these forms in stones invoke the figures of ancient scripts or superstitious imagery then they must also belie a deeper contract. The evolutionary

circuits have unwittingly (or intentionally) created the substrate for a special kind of inner reflection. They have built a machine for reconnection; a system for recoupling our distanced selves by fusing our inner and outer worlds. Figured stones are portals to the molten mantles of the psyche and all its dreamt-up denizens. And, best of all, these visions are suggested to us by nature – our imaginations' natural and most honest collaborator.

NOTES

1 Emperor Huizong of Song, the famous collector of stones, was the eighth emperor of the Song dynasty in China.

2 See *The Castle of the Pyrenees*, Rene Magritte, 1959.

3 The *Powers of Ten* films, written and directed by Charles and Ray Eames, depict the relative scale of the universe according to an order of magnitude based on a factor of ten, first expanding out from the earth until the entire universe is surveyed, then reducing inward until arriving at a single atom whose subatomic particles are observed.

4 Wu Daozi (680–c.760), also known as Daoxuan, was a Chinese painter of the Tang dynasty.

5 The term rheology was inspired by an aphorism by Simplicius (often misattributed to Heraclitus): 'everything flows' (πάντα ῥεῖ).

6 *A Land*, Jacquetta Hawkes, 1951.

7 Also known as Pietra Paesina, or Landscape Stone.

8 The Chinese word for marble is also 'Dali', named after the town.

9 Xu Xiake (d. 1641) was a travel writer and geographer of the Ming Dynasty who travelled through

China for most of his life until his death. His writings were compiled and published posthumously as Xu Xiake's *Travels*.

10 An automatic technique used by Ernst where paper or glass was laid over a painted surface and then pulled away to create random biomorphic and dendritic shapes.

11 This may have a scientific basis because iron oxide, which is contained in bloodstone, is an effective astringent.

12 Refers to banded rhodochrosite, which is mined in Argentina. It is also known as 'Rosa del Inca'.

13 Heliotrope translates to 'the turning of the sun'. The name came from the belief that when held in the rays of the setting sun, it would 'turn the sun' into a blood-red sphere. This ability of bloodstone to transform the sun's golden glow from gold to blood-red were attributed to its magical properties.

14 Bloodstone is also known as 'chicken blood' stone in China.

15 *The Festival*, H.P. Lovecraft, 1923.

16 'Kublai Khan', Samuel Coleridge Taylor, 1816.

17 The Hall of the Abencerrages in the Alhambra in Grenada, Spain.

18 See *Cyclonopedia*, Reza Negarestani, 2008

19 An ancient people of the North Caucasus around

the 7th century BC. (Also a race of mythical people living in perpetual mist and darkness near the land of the dead).

20 *Clew*: a ball of thread, yarn, or cord. The etymology of 'clue' (from Ariadne's thread).

21 *Kāla* (काल) is a word used in Sanskrit to mean 'time'.

22 *Tu Wan's Stone Catalogue of Cloudy Forest: A Commentary and Synopsis,*Edward H. Schafer, 2005.

23 This is based on a personal experience.

24 See The Yu-Ming lu, Liu I-ch'ing (from *The Story of Stone*, Jing Wang, 1991)

25 Mencius (372–289 or 385–303 BC) was a Chinese Confucian philosopher who was described as the 'second sage' after Confucius.

26 *Chimes of Empire: The Construction of Jade Instruments and Territory in Eighteenth-Century China*, Yulian Wu, 2019.

27 *The Story of Stone*, Jing Wang, 1991.

28 Though the concept of geological deep time was proposed by the Scottish geologist James Hutton, the term itself was coined by the writer John Mcphee in his book *Basin and Range*, 1981.

29 *Theory of the Earth*, James Hutton, 1788.

30 Up until his discovery the religion-centric worldview held that the age of the planet was a few

thousand years old. Stratigraphic signatures and compositions of rock gave rise to Hutton's revised estimation of hundreds of millions of years (still quite a way short of the actual 4.54 billion years we now know it to be).

31 'Hutton's Unconformity', *Transactions of the Royal Society of Edinburgh,* V (III), John Playfair, 1805.

32 'The Idea of Labyrinth (Migong) in Chinese Building Tradition', Hui Zou, *The Journal of Aesthetic Education,* Vol. 46, No. 4, 2012.

33 In a cellular automaton, a Garden of Eden is a configuration that has no predecessor. John Tukey named these configurations after the Garden of Eden of the Abrahamic religions, which was created out of nowhere.

34 Pancomputationalism is a view that the universe is a computational machine, or a network of parallel computational processes that follow discreet and fundamental physical laws.

35 'New evidence for an impact origin of Taihu lake, China: Possible trigger of the extinction of LiangChu Culture 4500 years ago', Zhidong Xie et. al., *AGU Fall Meeting Abstracts,* 2008.

36 The poem's title is 'A pair of rocks'.

37 See the section 'A Little History of Lithophilia'.

38 *Solanum torvum* and *Trisetum flavescens,* respectively.

39 Abbot Zhongfeng (1263–1323).

40 See *Between Dream and Shadow: The Aesthetic Change Embodied by the Garden of Lion Grove*, Hui Zou, 2018.

41 Ibid.

42 Vent Arrière, 1954.

43 In the modern era, however, stones are sometimes entirely manufactured from scratch to appear naturally eroded.

44 *The awareness of rock: East-Asian understandings and implications*, Graham Parkes, 2009.

45 *The Hidden Life of Stones: Historicity, Materiality and the Value of Candomblé Objects in Bahia*, Roger Sansi-Roca, 2005.

46 *Man and His Symbols*, Carl Jung, 1961.

47 The significance of the mythical hero is not lost on Jung, for the hero must descend to great danger to find their true self.

48 In Jung's dream we could say that the ontogeny of the psyche is recapitulated in its phylogeny. An unconscious encounter (inside a dream) becomes a key to unlocking the structure of dream symbology.

49 *Civilization in Transition, Collected Works of C.G. Jung*, Carl Jung, 1964.

50 *The Temptation of Saint Anthony*, Gustav Flaubert, 1874.

51 Chapter 57: Of Whales in Paint; in Teeth; in Wood; in Sheet-Iron; in Stone; in Mountains; in Stars.

52 'Max Ernst: Au de la Peinture', *Cahiers d'Art 6-7*, 1936.

53 *The Encyclopedia of the Dead*, Danilo Kiš, 1983.

54 *The Writing of Stones*, Roger Callios, 1988.

55 'Natur ist hiernach der sichtbare Geist, Geist die unsichtbare Natur', *Ideen zu einer Philosophie der Natur als Einleitung in das Studium dieser Wissenschaft*, Friedrich Wilhelm Joseph Schelling, 1797.

All line drawings by the author.

ACKNOWLEDGEMENTS

Special thanks to the editor Richard Skelton for his guidance and advice throughout the writing of this book. Gratitude to my early readers Paul Harris, Richard Turner, Thomas S. Elias, Mónica Belevan and Aashish Kaul for their useful comments and suggestions, and also to Rebecca Bligh for her diligent proofing and recommendations for improvements.

Eternal thanks to my daughter Zoe who always helps me to see the world afresh, and to my mother Florence for her loving support and encouragement over the years.

INDEX

CPSIA information can be obtained
at www.ICGtesting.com
Printed in the USA
LVHW012238241022
731386LV00008B/372